MASTER CLASS PHOTOGRAPHY SERIES

IMPROVING YOUR COLOR PHOTOGRAPHY

Joe Marvullo has traveled the world in search of color photographs. His work has appeared in many publications, including *Popular Photography, Modern Photography, Camera 35,* and *Exclusif.* Among his many clients are British Airways, Swiss Air, Sabena, Hasselblad, and Nikon. He has also been a consultant to Hasselblad, and has toured the United States for the famed Nikon School. Particularly well known for his stunning travel photography and book jackets, Mr. Marvullo is based in New York City.

The Master Class Photography Series
Better Black-and-White Darkroom Techniques
Creative Still Life Photography
Improving Your Color Photography

MASTER CLASS PHOTOGRAPHY SERIES

IMPROVING YOUR COLOR PHOTOGRAPHY

Joe Marvullo

A SPECTRUM BOOK

PRENTICE-HALL, INC.
Englewood Cliffs, New Jersey 07632

For Teri

A Quarto Book
Text copyright © 1982 by Quarto Marketing Ltd.
Photographs copyright © 1982 by Joseph Marvullo

Project Editor: Sheila Rosenzweig
Production Editor: Gene Santoro
Design Assistant: Effie M. Serlis
Produced and prepared by **Quarto Marketing Ltd.**
32 Kingly Court, London W1, England
Printed in Hong Kong

This Spectrum Book is available to businesses and organizations
at a special discount when ordered in large quantities.
For information, contact **Prentice-Hall, Inc.,**
General Book Marketing, Special Sales Division,
Englewood Cliffs, N.J. 07632.
A Spectrum Book
10 9 8 7 6 5 4 3 2 1

ISBN 0-13-453522-7
ISBN 0-13-453514-6 (PBK.)

Library of Congress Cataloging in Publication Data
Marvullo, Joe.
 Improving your color photography
 (The Master class photography series)
 Bibliography: p.
 Includes index.
 1. Color photography. I. Title. II. Series.
TR510.M33 1982 778.6 82-10117
 AAcr2

CONTENTS

1
Color Vision

COLOR IS A VITAL ELEMENT IN THE CON-struction of any photographic idea, since we see life in varying degrees of color vision. Our visual senses are stimulated by color: its brightness or dullness, harshness or beauty—even its apparent absence. For the photographer, an awareness of color in all its moods and combinations is necessary to taking good color photographs. For most of us this means that we must learn to look at colors afresh and in particular, to study the effects changes in natural light have on the colors around us. Bright afternoon sunlight, for example, with its high contrasts, deep shadows, and bursting colors, shows colors at their fullest potential. The clear details and heavy outlines in this light create strong color renditions and definition, and the uneven distribution of the light and shadow can produce an uneasiness, or color tension. At the opposite end of the pole is the mild gradation of light that exists before and after the sun rises and sets, when the softness of the light and the serenity of the colors produce a uniform calmness. Colors do not jump out, they do not scream for attention; the muted lighting creates a limited palette of pastel colors, merging even the strongest color contrasts together.

It is natural that the color atmosphere of a scene should play a major role in its recording on film. Graphic interpretation by the artist is the essence of the idea, the concept behind the camera. But whether you are documenting life through people and personal portraits or creating a still-life treatment of an inanimate object, color is a key factor in the delivery and realization of your pictorial ideas. An awareness of color themes, and of its strengths and weaknesses, will enable you to see your surroundings as a palette with any number of combinations, all of which can be employed to enhance your subject to illustrate your idea photographically. To learn to see color as a natural force, with its relationships and influences on any given subject, is not only vital to good color photography; it is to go with the order of things.

LOOKING AT COLOR

The word *photography* is derived from the Greek language, and means literally "to write with light." A basic understanding of what light is and how it behaves should be your first step in preparing yourself for the skillful handling of pictorial situations.

Light is a visible form of radiant energy, a small part of the electromagnetic spectrum that ranges from X-rays through radio waves. All light, whether natural or artificial, is created by the emission of photons. For example, when the filament of a lightbulb is stimulated by an electric current, the atoms of the filament oscillate from a lower to a higher energy level and back again. As the atoms drop back to a lower energy level, they emit photons, or packets of light energy.

Photons travel in waves. Photons of different levels of energy make up light of different wavelengths; the particular wavelength of light determines its color. The most energetic and shortest are the blue wavelengths, while the least energetic and longest are the red wavelengths. White light is a mixture of photons of wavelengths that cover the whole range of visible light; that is, white light consists of all colors.

When light strikes an object, it can be reflected (thrown back at the same angle), as by a mirror; refracted or scattered, as by water; or absorbed, as by most solids.

Lightwaves bounce off smooth, polished surfaces, like metals and mirrors, in an organized fashion; as with a bouncing ball, the angle of incidence is equal to the angle of reflectance and produces an exact image.

Clouds are made of transparent water droplets, but appear as white forms due to the refraction of light. Lightwaves refract haphazardly through the droplets and are also reflected off the surface of the water. The result is a white haze (the presence of all colors).

Sunlight, containing wavelengths of all colors, is bent when it passes through the earth's atmosphere, which contains tiny particles of water and dust. This scattering affects the shorter waves at the blue end of the spectrum more than the red, with its longer wavelengths. Therefore at noon, when the sun is directly overhead, we see the sky as blue, the sun as yellow, and daylight as white. When the sun is low on the horizon, at sunrise and sunset, its lightwaves encounter more atmospheric particles. More blue light is scattered and the surviving red waves predominate, creating an orange sun and a reddish glow to the sky. In fact, since the amount of scatter and distribution depends upon the amount of particles in the atmosphere, the most spectacular, fiery sunsets often

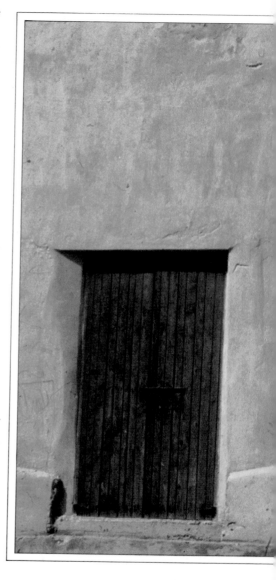

This richly textured wall, photographed in
Morocco, illustrates clearly the particular
properties of bright afternoon light. The
purity of the white, exposed directly to
the overhead sun, contrasts with the
richness of the pink and green tones in
the open shade. The warm tones of the
wall are dominant and reflect the sunlight.
A 105mm lens and Ektachrome 64
pushed to ASA 250 bring out contrast.

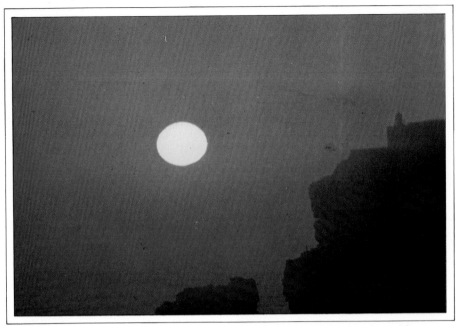

occur because of heavy concentrations of pollutants in the air.

Depending on its molecular structure, a solid object generally absorbs some part of the light that falls on it and reflects the rest. The color we see is what is left of the spectrum after the other colors have been absorbed or subtracted. We see a lemon as yellow, for example, because a lemon absorbs all the visible wavelengths except for those that make up yellow.

As Sir Isaac Newton first demonstrated in 1665, a prism separates white light into its spectrum of component colors by bending each wavelength (color) to a different degree. This spectrum of colors can be re-collected through a second prism to make white light. The colors of the spectrum blend into one another, from violet through blue, green, and yellow to red. A good way to visualize color relationships is to imagine a spectrum bent into a circle, or color wheel, joining the blue and red ends. Colors opposite each other on the color

Sun and sea in Portugal, shot with a 400mm lens and Kodachrome 25, provide a powerful example of the natural bending of lightwaves in the spectrum. Because red wavelengths are longer, they scatter less; this, combined with the mist of the ocean (diffused light), produces the orange haze that is evenly distributed throughout this picture.

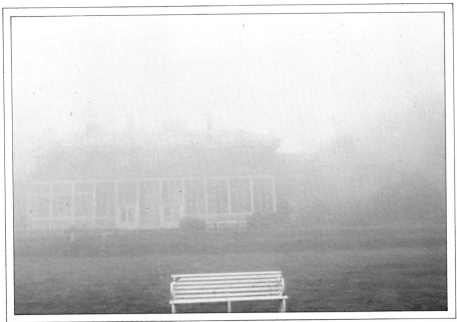

A low camera angle, to eliminate extraneous background, accents the mystery of this fog-shrouded scene of a manor house in England. To convey its eerie quality, exposure was increased by one stop so that the overall brightness of the scene was preserved and the most made of the reflected white light. Ektachrome 400 was used with a 50mm lens.

wheel, such as blue and yellow, are complementary. The principle of forming colors by *combining* parts of the spectrum is called additive color mixture, or color by addition. It is one of two ways to mix colors and can be used only with colors in the form of light. Red, blue, and green are the primary colors of light; by mixing them you can form any color in the visible spectrum; when combined equally they form white light. Each of the primaries has its complementary color—yellow is the complement of blue, magenta of green, and cyan (blue-green) of red. When combined, a primary together with its complement will form white light, since a complementary color can be formed by combining the two other primaries: yellow, for example, is formed by combining green and red. Additive color is the principle behind color television sets, but actually has very little to do with color photography.

The other way of mixing colors involves *subtracting* parts of the spectrum

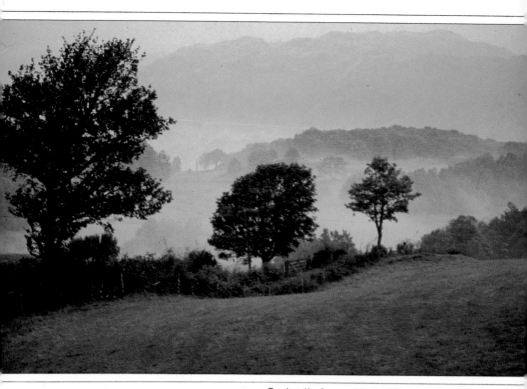

from white light. It is called subtractive color mixture, or color by subtraction, and forms the basis for almost all color photography.

All color film (slide and negative) is composed of three main layers, each sensitive to one of the primary colors. Together they can respond and reproduce any color in the visible spectrum. The film itself is a stack: the first layer is sensitive to blue light, the second to green, the third to red. After the first layer records blue light, a filter layer of yellow material screens out excess blue; green is recorded next. The third layer records red, and finally a layer known as the anti-halation block is used to absorb all the remaining light.

The three separate images formed on the film are not actually colored; they are dyed in the development process. The chemical developer changes the exposed salts of the film to metallic silver so that a silver image forms on each layer of emulsion. Within each layer a

England's famous Lake District, with its rolling hills and late evening mist, offers stunning opportunities to utilize depth of field. The mist here is amplified and made into an added compositional element by using a telephoto lens. A 200mm lens and Ektachrome 400 compressed the deep greens of the foreground and the vague images and subtleties of the background into a unified composition.

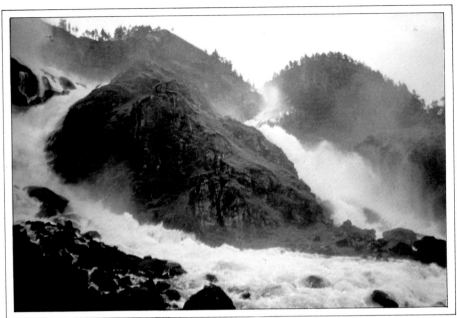

How mood can be visualized as a force of nature is apparent in the rushing torrents of this waterfall in Norway. Different depictions of water depend on your choice of shutter speeds. Slow speeds, with Kodachrome 25 and an 85mm lens, as used here, heighten the dramatic aspects of a scene because they create gushing whites in motion; faster speeds freeze the action for a very different effect.

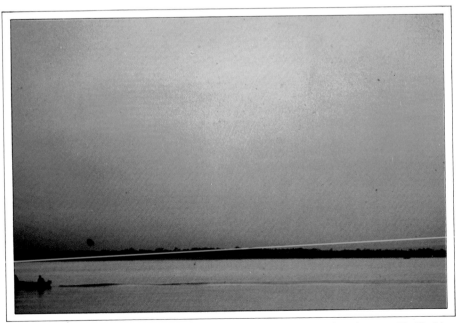

The serene quality of side light and the reflectance of sunset's afterglow on this Florida lake silhouette the men in the boat. The warm air of tranquility here contrasts sharply with the violence and cold monotones of the waterfall in the shot above. Kodachrome 64 was used with a 180mm lens.

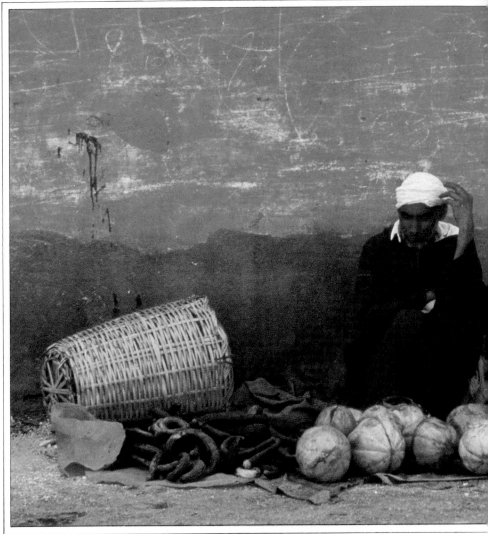

Certain colors (earth tones, browns) trigger almost universal responses, as is apparent in this portrait of a fruit vendor beneath the walls of Marrakesh, where the ambient light creates an earthy feel. The 105mm lens helped isolate the subject from unwanted details, and Ektachrome 64 was pushed to ASA 250 for added contrast.

chemical substance called a coupler joins with the chemicals in the developer to form a colored dye; each layer forms a different dye. These dyes are the complementary colors of the colors originally recorded. When white light, which contains the three primary colors, is passed through the complementary color (as when a slide is viewed through a projector), the primary color is filtered out and the original color is reproduced. (For more information on types of film, see Chapter 3).

Color and light, as they pertain to photography, have many complex aspects. A basic understanding of these remarkable characteristics, plus the skills of the creative photographer, make the recording of all aspects of life on color film something unique and wonderful.

THE MOODS OF COLOR

A scene appears to us as in a dream: mist is rising, colors are muted, our field of view is limited by a gentle overriding haze, the colors are unlike those we see normally, the setting is ethereal—the scene has created an emotional response. This is what mood or atmosphere is in color photography: setting a visual tone and capturing a flavor, inducing a feeling of romance or mystery, warmth or tension, aggression or peace. The atmosphere of the scene or subject is the backbone of any photograph, and capturing it on film using color, light, and composition together to express a pictorial idea is the aim of good photography. To begin, you must understand the moods of color, how they can vary with changes in light, time of day, weather conditions, even season.

In essence, all intelligent photographs are mood shots, for they all strive to interpret or document a particular feeling. However, there is a special category of atmospheric photographs that can work simply because of the conditions that prevailed at the time, and certain

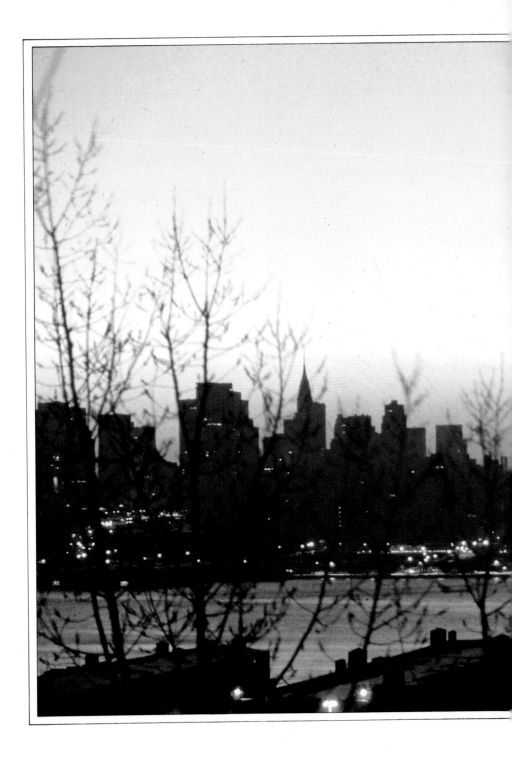

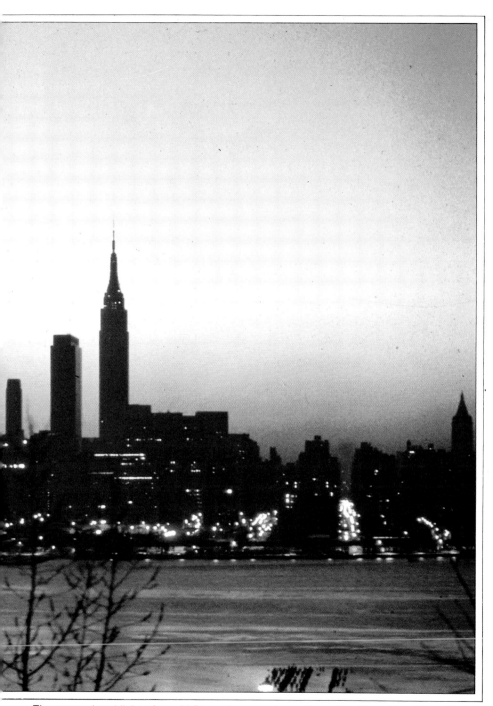

The rose-colored light of a cold December morning softens the silhouette of New York City's famous skyline, seen from across the Hudson River. The clarity of the air, because of the winter's chill winds, eliminates any diffusion due to haze, and instead allows a clear interplay of the shorter, scattered wavelengths at the ultraviolet end of the spectrum with the longer, more penetrating reds and greens.

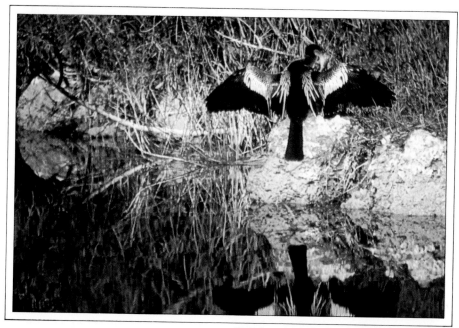

This heron in the Florida Everglades illustrates the fresh color and brightness characteristic of morning light. The air here is particularly clear, allowing use of a 500mm lens; details of the foliage and reflections are enriched by side lighting. The film is Ektachrome 400.

emotional responses that they induce. These are discussed below.

THE COLORS OF DAY AND NIGHT

Light is color. Without light there is black; there is no visibility, no perception of form, shape, distance, or perspective. To the photographer, the whole stage of creative existence translates into the language of light. The quality of light changes with the passage of time, day into night, night into day; with it changes the face of the world. Colors are born, mature, ripen, and fade with the day. The creative photographer must be aware of the changes in the quality of light to exploit the particular characteristics of light that will best render specific photographic themes. As the day passes, as the seasons change, as the weather changes, as you move to different places, the light changes as well.

Since the earth rotates one revolution of its axis every 24 hours, the direction and color of the light reaching the earth change through the day as the sun seems

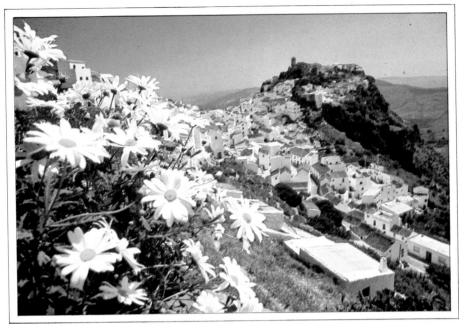

to change its elevation in the sky. From the first light of dawn creeping over the horizon, to the stark overhead light of the noonday sun, to the last rays of a disappearing sunset, the sun's light is bent, more or less, as it travels through the earth's atmosphere. This bending, as we have discussed, determines the color of the light we see.

Pre-dawn. The colors of pre-dawn are essentially monotonal and flat. The light of the new day is in its infancy, and any color is weak and gentle; the mood is cool, and there is a dominant atmosphere of stillness and quiet. The low light levels provide a one-dimensional backdrop for shadowless subjects, with little contrast and shallow depth of field. This is still basically the world of black-and-white monotone, but it will change quickly to the world of color.

Dawn. The world of grays comes to an end when the first touches of light begin to appear. The scene begins to take on a new shape and form as the sun rises above the horizon and casts a directional

Shooting this mountain town in southern Spain at midday with a 24mm lens on Kodachrome 25 at $f/16$ maximized the depth of field. The pure white light of midday can allow great flexibility with depth of field, because its intensity permits the use of smaller apertures with subjects that don't require delicate modeling. Outline detail is superb, and filtered effects work well in bright afternoon light; in this case a polarizing screen was used to deepen the sky.

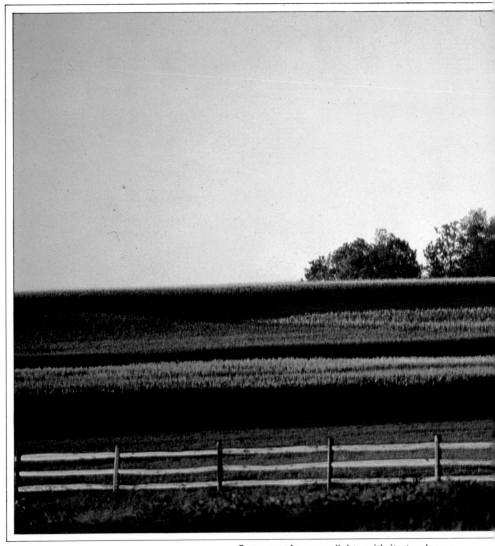

Summer afternoon light, with its tendency toward the longer wavelengths of the spectrum, creates the warm colors and rich modeling evident in this shot of the Pennsylvania countryside, taken with a 105mm lens and Kodachrome 25. The glittering highlights on the wooden fence, the receding hills textured and molded by the side light, the overall presence of space and depth, are the typical ingredients found when the daylight hours have grown old.

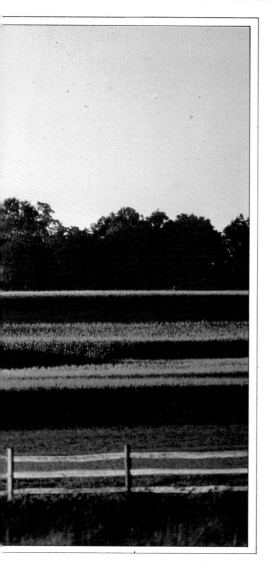

light. There are still dark shadows and the prevailing colors are deep blues, but now new, vibrant, warm colors wash across the sky; with them come the first visual details of the day. Be prepared to adjust your exposure continuously as the light changes.

Morning. The first warming glows of the amber-yellow light of morning, crisp and clear, embrace all subjects in the beautiful, basking warmth of their side-light. Textures come to life; it is a world of color for the first time. Details are personalities, not shadows; forms have dimensions, there is shade. The light is no longer strongly directional, and gives subjects depth and detail; they are no longer flat silhouettes.

Midday. When the sun is directly overhead and its full intensity at its highest elevation reaches the earth as white light, colors are perceived at their truest. Though the light is coming straight down and is somewhat flat, it produces details and outlines of forms and shapes with absolute clarity. The light of noontime, especially in summer, doesn't lend itself well to good, interesting photographs. It is often stark and harsh, with hard shadows, as if the sun were a giant spotlight. But you can still achieve interesting effects by using unusual angles and strong shapes that can benefit from the dimensionless light. At this time of day, contrast and shadows form black gaps in perspective views of landscapes, making panoramic shots confusing to the eye. But rewarding results can be obtained by using color as a main theme for close-ups and details. The intense light shows colors at their strongest, but washes out weaker colors and creates strong shadows. Intense light also creates beautiful shades of reflected light when it bounces off various planes, such as beaches, rooftops, and snow. This is the toughest time of the day to find what you want, but when you find it, the technical aspects of photographing it

(as far as depth of field and exposure are concerned) are manageable, since color film is balanced for this type of midday reflectance. For best results as far as color accuracy and exposures are concerned, do what the instruction sheet included in the film package says: keep your back to the sun. If the sun is overhead, either wait, try to change your angle, or work with it.

Afternoon light. The interplay of shadows and highlights, the richly endowed colors of late afternoon light, add a new dimension to the perception of both perspective and color in the living scene. It is sidelight at its grandest scale, the sun at a low angle and declining with time, colors basking in an orange type of light quite unlike the morning's light-amber tones. Now there are deep divisions in the landscapes; long shadows and saturated hues mix together to make this time of day the "painter's light." Light plays a major role in the separation of space. Volume and depth are the key to the landscape; patterns take shape, commonplace objects take on the radiant warmth of the sun at its most penetrating angle. The scenes before you become three-dimensional in their form because of the sidelight's "sculpting" quality. Glints of light shoot through openings in streets, light filters through the spaces of trees, and hills are molded with shading and detailed textures, all with shadow as an active element of the photograph. Exposure changes quickly as the light fades. As shutter speeds must become slower and slower, now is the time to go to a tripod or a faster film. It's a good time for backlit shots. The angle of view becomes all important as you try to make the most of every available opportunity, because the world is now extremely photogenic, and time is working against you as the sun gets slowly lower and the shadows get steadily longer. It is a time to shoot pictures.

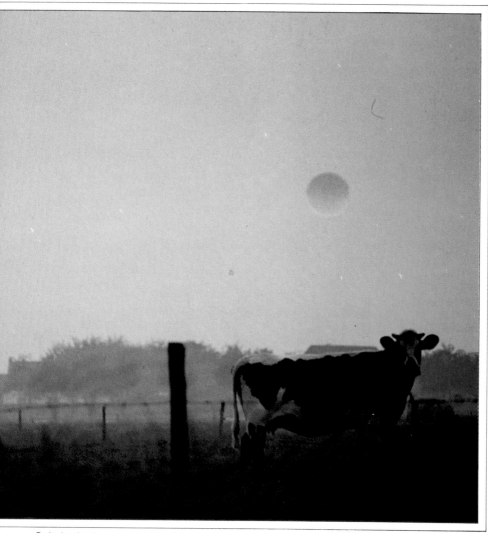

Only in the last moments of day before sunset does color again assume such subdued and washed-out hues as it had in the very early morning, allowing for some interesting compositions and effects. This scene of a farm in Gettysburg, Pennsylvania was photographed with an 85mm lens and Kodachrome 64.

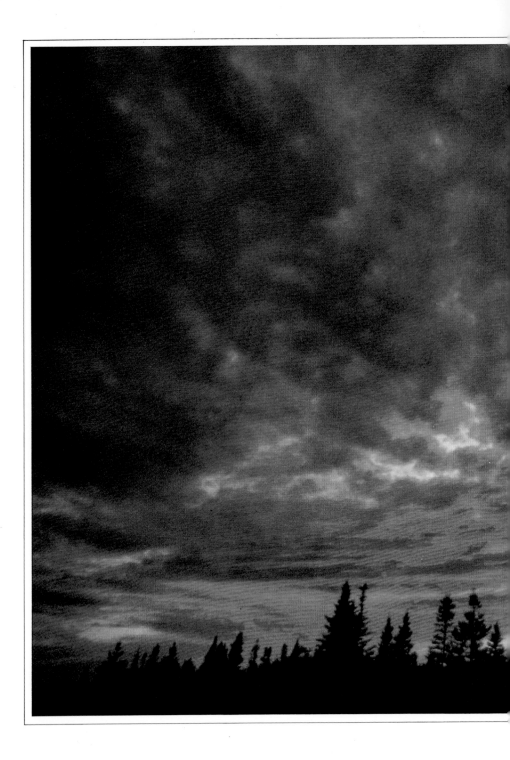

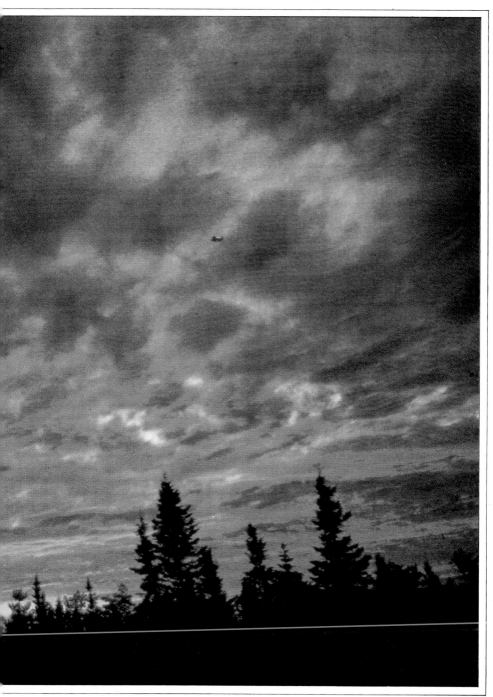

When the "hot" colors of the spectrum glow richly at the end of the day, look for interesting subjects to position as silhouettes. Work fast and shoot a lot; the light around sunset changes literally minute by minute, and creative use of exposure and aperture can produce spectacular results. Here, a wide-angle lens tilted upwards catches a vast expanse of the sky in this summertime sunset in Canada.

The longer the time exposure, the greater the range of unknown colors and effects. The stray light that so beautifully composes this shot of a mountain lake in Vermont was scooped up by a 300mm lens on a tripod, shooting Ektachrome 400 at a five-second time exposure.

Sunset. The most spectacular, evocative photographs of daylight at its full potential can be made at sunset. Since the red lightwaves dominate at this time of day, the sky becomes a canvas of changing, raging color. Since you are at the limits (and in most cases past it) of the film's ability to render color accurately, you are now in the realm of impressionistic color and reciprocity failure, whether you want to be or not. Be pre-

pared for surprises when you view the processed film. (See Chapter 3 for a complete discussion of reciprocity failure.) When you are photographing sunsets, all focal lengths work; telephotos for huge sun disks and close-ups of clouds, wide-angle lenses for miniaturizing landscapes and subjects. Great sunsets happen everywhere: cities, deserts, beaches, oceans — in winter through summer. Spectacular effects can be seen in cities in the summer when there are low cloud ceilings and the dust particles and debris of the atmosphere are amplified by the heavy air and setting sun.

When atmospheric conditions such as low-hanging clouds exist, another type of condition affects the colors of the setting sun and its role in the sunset photograph. Because the light is scattered and diffused, the low-energy wavelengths of the other colors do not penetrate the low ceiling of moisture; only the very weak surviving red wavelengths make it through in the shape of the sun. The deep grays and muted tones of the scene are contrasted only by the dim red sun. This is the last time of day for long hand-held exposures.

Last light. Once the sun is down the first colors of night have appeared. These are cool colors that bring refreshment from the hours of white light. Time exposures of several seconds are needed, capturing a color rendition that is more affected by the reproduction capabilities of the film than by the wavelengths of light that are actually present. Color casts caused by reciprocity failure (see Chapter 3) can be seen. This is the world where the camera can see color and light that did not exist at all.

Time of day has a tremendous effect on light and is the primary factor to consider when planning a photograph. But other factors, such as the weather, the season, and the geographical location, all affect the quality of light. Compare the molten colors of a lingering summer sunset to the sudden disappearance of the dim winter sun. Compare the haze of an autumn afternoon to the mist of a spring morning. Compare a short, gloomy winter day in Paris with a sunny, long one in Haiti. Sometimes markedly, sometimes subtly, the light varies. You must appreciate why and how it changes, and make the most of it.

2
Color
Composition

THE VISIBLE WORLD WE LIVE IN CONSISTS OF colors that are familiar to us through our experiences. Simple messages are imparted by certain colors. Green is seen as natural and restful in a landscape, but the green cast on the face of a person photographed under fluorescent lights is unnatural and eerie. Blues are tranquil and natural, cool and relaxing, but can create a mood of melancholy when they predominate. To use color effectively in your photography you must learn about the moods of color so that you are able to make artistic judgments on what to include and exclude from your composition and how best to exploit the design characteristics of color.

Like good painting, good photography must have a solid framework to make a successful visual statement. The use and balance of light and dark, colors, shapes and forms, line, perspective, and points of focus that direct the eye to a spot in the picture are all aspects of a unified composition, one that is organized and pleasing to the eye.

The fundamental elements of good composition can be broken down into some basic building blocks, along with some basic principles for combining them. Consciously think about composition when you shoot. Look carefully at your shots and decide exactly what it is that makes them good.

FILLING THE FRAME

How you choose to fill the frame and divide the picture area is the first step in composition. Consider the subject carefully through the viewfinder. The first decision to make in 35mm photography is whether the shot should be vertical or horizontal. Generally, subjects with strong vertical elements are most attractive when shot in a vertical format; the same holds for horizontal subjects and the horizontal format. But there are other considerations. Look at the scene both ways. Which way will fill the frame more, or exclude more extraneous detail? Which way will give more pleasing proportions? As camera angle and height change, the best format may change as well. Constantly look through the viewfinder, trying both ways.

Next, move in on the subject. Look at it from different positions, raising and lowering the camera and trying out different angles. Search for the point that will fill the frame, avoiding needless emptiness in the foreground or background. Find striking angles that shadow an unusual or revealing aspect of the subject, and be sure to vary the camera height. Nothing is more uninteresting than a series of photos all taken at eye level.

The human eye concentrates on what it finds interesting in a scene, to the exclusion of all else. This leads to a tendency to see only what you want to see in the viewfinder. The camera, however, records everything at which it is pointed. When planning your composition, look at all the elements and not just the main subject, consider how they relate to one

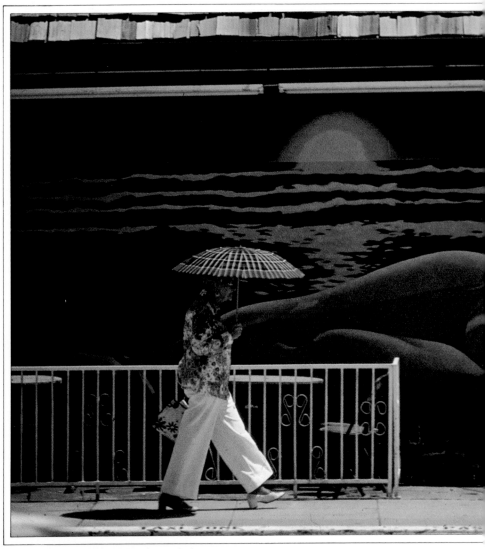

This incredible wall graphic of a nude in Hollywood, California, would have been subject enough, but the woman strolling by with her multicolored umbrella adds a touch of offbeat humor that brings the shot to life. Compositionally, subjects on the left of a scene appear as if arriving, while, conversely, those on the right side seem to be leaving. The shot was taken with a 180mm lens at $f/2.8$ using Kodachrome 64.

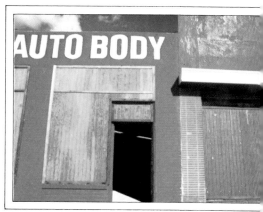

The golds and blues of this auto body shop in California exemplify how geometric design can be combined with a leaning perspective to give a composition an upward slant. The leaning perspective intentionally gives the composition a feeling of motion that is achieved solely through design. A 28mm lens was used with Kodachrome 25.

Pulling in detail with a telephoto lens can make a thematic design possible. The vertical detail of this white yacht was chosen because of its strong geometric shapes, shadows, and crossbars. Extracting a visually descriptive detail from a scene without showing the whole subject is a technique of composition that can show, in simplified form and graphic manner, the essence of a scene. A 200mm lens and Kodachrome 64 were used.

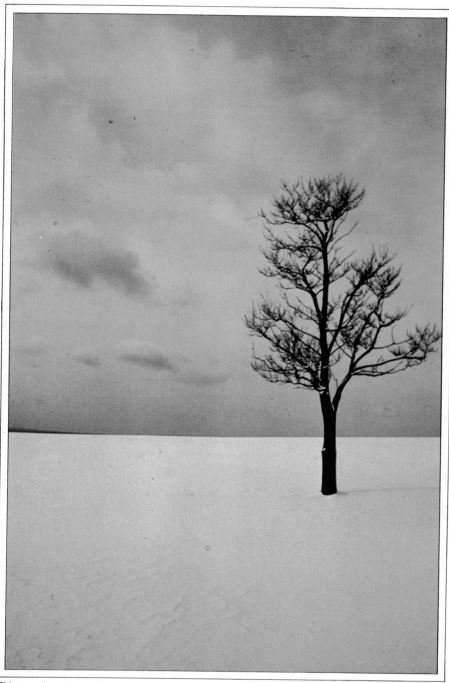

This tree in snow, photographed on a winter beach, uses the horizon to show infinity at a predetermined point. A low angle was chosen with a 20mm lens. The placement of the tree off-center and the horizon a little lower than halfway down the frame brings the viewer's eye directly to their intersection and thus to the tree, while balancing that dark shape with the white snow on the right. The sky heightens the feeling of depth, since it occupies more space in the frame than the ground.

The composition of this picture is split into thirds: the Moroccan fruit vendor on the left, the foreground fruit in the middle, and the remaining background mounds on the right. The triangular shapes of the fruit are used throughout the picture: the man placed purposely on the left simulates yet another triangular shape. The overall warm color adds to the harmonious cohesion and ease of the design. A 55mm macro lens and Ektachrome 64, pushed to ASA 250, were used.

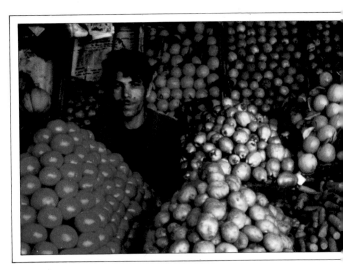

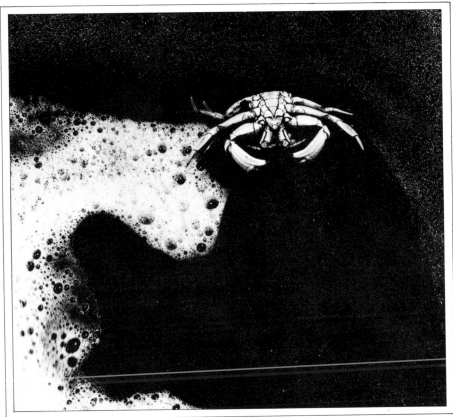

Since the crab was placed above center, the subject was enhanced by the three surrounding free-form masses: the advancing, contrasting whites of the sea foam, the blacks of the the sand that cover the lower left, and the highly textured grays that cover the upper right and serve as the main backdrop for the crab. The view looking down adds concentration on the immediate area by eliminating disturbing backgrounds. The shot was taken on Tri-X film with an 80mm lens on a medium-format camera.

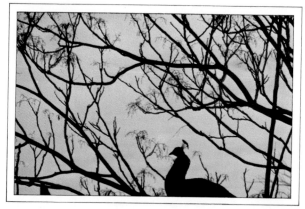

In this moody shot of a peacock against a gray winter sky, taken with a 35mm lens on Ektachrome 400, color is reduced to a secondary element in the design. The placement of the bird in the lower right corner leaves the eye free to watch the natural forms of the silhouetted tree reach across the whole composition.

another, and change your angle or lens to exclude unnecessary elements. You will reap two benefits from this: your shots will include less distracting clutter, and you will develop a sharp eye for telling details.

The best pictures are often the simplest — those with a strong point of interest. This does not mean, however, that the main subject of your picture must always be in the center of the picture. Often it will be, and the picture will be a good one. But centering the subject can also lead to boring symmetry in your composition, an effect desirable only if symmetry is what you wish to stress.

Often the most pleasing proportion for a picture is a ratio of one part to two. Although by no means a hard-and-fast rule, this ratio is an important one. Try to position the main subject to divide the picture area into a one to two ratio. For example, a landscape divided across the middle by the horizon is an unnaturally symmetrical composition. A landscape that is about two-thirds land and one-third sky shows more balance and provokes interest.

SHAPE AND FORM

In compositional terms, shape is the two-dimensional outline of an object. Shapes lack depth, but can be powerful pictorial statements. To emphasize a shape, give priority to it as a single visual element. A good way to do this is to use a straight-on camera angle and fill the frame with the shape. Look for strong contrasts of color between the shape and its surroundings, and try to position the shape against a simple background. Strong, direct lighting that defines the shape and casts sharp shadows often gives the most striking results. Dark shadows can also be used to stress shape by creating a black background.

Shadows and silhouettes are pure shape — flat and dimensionless. Silhouette is one of the simplest and most dramatic ways of emphasizing shape. Just place the subject against a bright background, and expose for the background: the subject will go black. For more detail in the silhouette, expose midway between the subject and the background.

Form is shape given depth by a change of perspective or lighting. By choosing a different camera angle, one that shows more than one plane of the subject, you create a three-dimensional effect. Light that gives shadows, especially soft light, will also create dimension. Diffuse or soft light is particularly good for bringing out delicate shapes and subtle curves. It is the ideal light for nudes, sculptures, and the like. Stronger, more directional light will tend to create

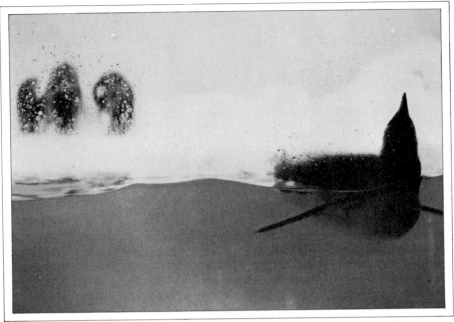

The design shaping this photograph of penguins, taken with a 35mm lens on Tri-X at the Bronx Zoo in New York City, suggested itself because of the placement and form of the main subject, a negative space silhouette. The grays recede into the background, and the massive form of the subject is balanced by the shapes on the left-hand side of the frame.

simpler, often more abstract shapes, with less detail. This kind of light is good for strong, graphic subjects, such as buildings. For translucent forms, such as flowers, cloth, colored glass, or similar subjects, gentle backlighting is excellent for bringing out curves and edges. As when photographing shapes, choose simple backgrounds and uncluttered subject areas.

LINE

Line by itself is a powerful compositional tool, particularly when seen as an aspect of shape. By definition a line is flat and two-dimensional, yet line is extremely effective for adding depth or tension to a composition.

Look for bold lines that create unusual divisions within the frame, or lines that interact strongly with one another. Either can create intriguing abstract designs. Lines that run obliquely across the

frame generally create a stronger sense of motion than those that are horizontal or vertical (sympathetic to the lines of the frame). Move in close and use an angled viewpoint.

Stark, flat lighting brings out strong lines. Curved lines usually seem soft and sensuous, and are useful for creating a sense of relaxation and calm. These qualities are often dramatically emphasized by directional light.

Line is also a good way to direct the viewer's eye. Dynamic or converging lines that lead to the subject give the viewer visual cues about what is important in the composition. Look for elements in the foreground or background that point toward the subject, and find ways—by changing camera angle, for example—to incorporate them. This may mean raising or lowering the camera to compress or expand the lines, or seeking an unusual point of view, or switching

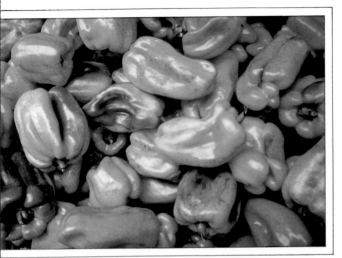

Harmonious composition, both in color and conformity of shapes, is displayed in this photograph of green and yellow peppers. Since the various components were so similar, moving in close for details was most effective for structuring the shot. The result is a study of light and form, concentrating on color nuance. It was taken on Kodachrome 25 with a 35mm lens.

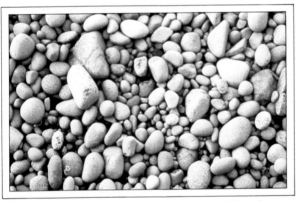

The molding by early-morning side lighting of this close-up of smoothly rounded rocks on a Crete beach uses shading and detail to bring out the shapes as forms of interest. If photographed using overhead light, the rocks would have seemed flat and nondescript; this angle of view, shooting straight down, adds texture to each individual stone as well as enhancing the overall design. Kodachrome 25 and a 50mm lens were used.

Curves in a composition give a loose and natural feeling. As a design feature, curves tend to lead the eye across a picture at a slower pace, while strong lines take the eye directly to the center of interest. This sand shark was photographed using an 80mm lens on a medium-format camera with Tri-X film:

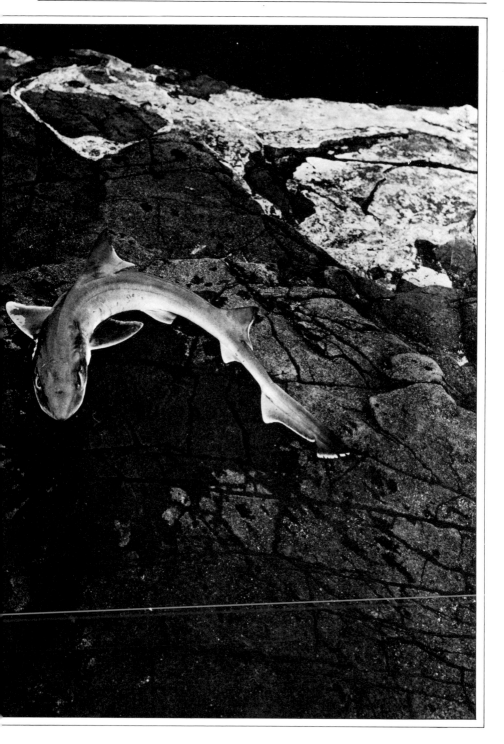

Geometric color designs offer unusual looks at ordinary colors and shapes. They are purely aesthetic, relying heavily on the use of color and line to present an abstract cropping. Here the geometric composition of blue- and gold-colored walls in Portugal are a deliberate use of color and line as a statement of design harmony. I used a 105mm lens at f/16; the film was Kodachrome 25.

to a wide-angle lens to include lines in the frame.

PERSPECTIVE

The relationship between foreground and background and the interplay between depth and space are what give a three-dimensional quality, or perspective, to your two-dimensional image.

Diminishing size and converging lines are the essence of perspective. Objects appear to get smaller as they get farther away; the greater the contrast in size between foreground and background elements, the deeper the scene appears to be. In addition, parallel lines seem to converge toward a vanishing point as they get farther away.

By carefully choosing your viewpoint and the focal length of your lens, you can use scale and line to their fullest. Converging lines are lengthened by a low camera angle aimed upward; conversely, they are foreshortened by a high camera angle looking down. In the same way, foreground elements will appear larger if the camera is aimed upward. Be careful not to overdo this. When the film plane of the camera is no longer parallel to the plane of focus, distortions such as keystoning result, particularly with objects close to the camera.

Wide-angle lenses stretch perspective,

making the size differences between the foreground and background elements seem greater than they are. Moderate wide-angles do this in a natural-looking way; extreme wide-angles and fish-eyes create more obvious distortion. Wide-angle lenses are particularly useful for tying a composition together and giving a sense of scale, because the great depth of field they provide allows a close foreground object and a distant background element to both be in focus, showing their relative sizes accurately. By including foreground detail, you link distant subjects together and strengthen the sense of perspective.

Telephoto lenses have a flattening effect, compressing the distance between foreground and background. A moderate telephoto will do this in a realistic way, while long telephotos have a foreshortening effect, making background elements seem much closer and larger than they are. This is effective in some cases; for example, to fill the frame with the glowing disk of a setting sun. To stress perspective with a telephoto, use the smallest apertures possible to give sharp focus to both the foreground and the background.

A scene need not have converging lines or diminishing sizes to have a strong sense of perspective. Because of

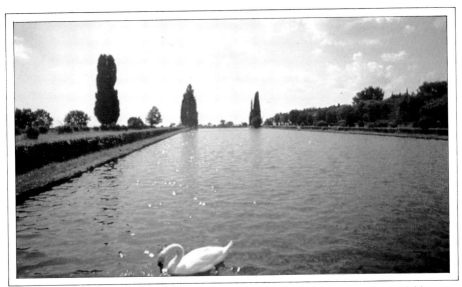

The sense of space in this shot was stretched by the wide-angle lens: the vanishing point was the end of the pool. The converging lines appear natural, and the swan is balanced by the vanishing point. The 18mm lens makes the most of the distance between the main subject and the horizon line. Kodachrome 25.

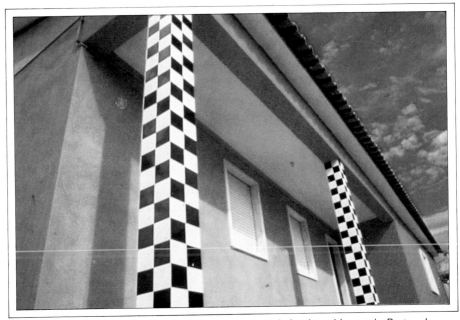

The acute angle of view in this shot of an orange and checkered house in Portugal shows how bright colors can add punch to this triangular composition. Converging lines meet at the bottom of the right-hand corner; the deep blue sky makes the vanishing point the base of the triangle. Taken with a 24mm lens, polarizing screen, and Kodachrome 25.

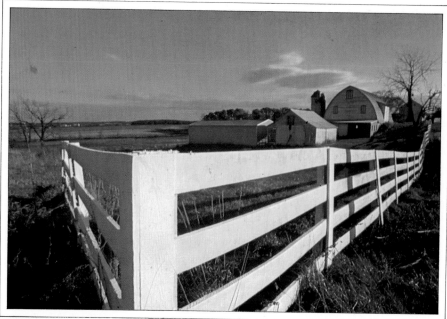

This stark white fence, starting left of center and continuing towards the horizon line, is a strong example of the effective use of linear perspective. The country scene of blue sky and green grass is transformed by the powerful and exaggerated (by an 18mm wide-angle lens) proportions of the fence running from foreground to background. The sky of this scene in Pennsylvania seems normal, but the fence does not. However, both are tied together and given depth by the receding lines.

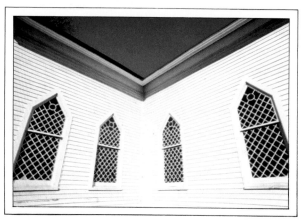

Triangular composition and converging lines combine with blue and white in this graphic interpretation of an old New England church. All the elements lean toward the center; the perspective lines meet above the center of the photograph in this unusual angle of view; the wide-angle lens gives movement to the picture by making the windows lean and stretch. The eye heads directly to the "V" made by the blue sky and white building. Shot on Kodachrome 64, using a 21mm lens.

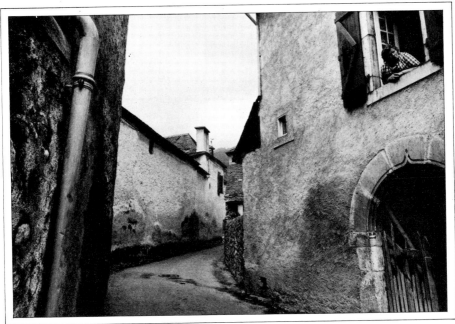

Angle of view is a basic compositional tool for exploiting line and perspective. The exaggeration of space provided by a super-wide 15mm lens converts a narrow passageway in a French mountain town into a leaning "imaginary" perspective. The eye is directed toward the center; the black negative space of the doorway on the right balances the detailed shapes and forms of the wall that covers the left to center portion of the picture.

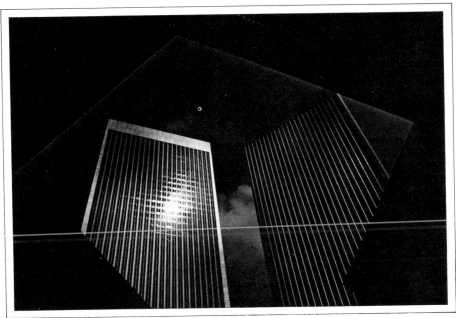

Negative space and exaggerated angular perspective as it appears with straight lines are seen in this shot taken in Century City, California. The upward angle of view is framed by the negative space of the corners. An 18mm lens was used with Tri-X film.

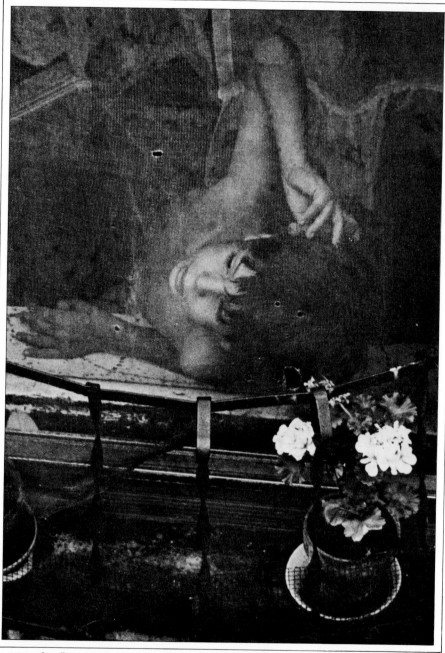

To cover the distance of an urban alley and catch the little boy day-dreaming on a hot summer's day, I used a 300mm telephoto lens. Placement and texture are the main components of the composition. The boy, the negative space, the textured bricks, and the lace curtain are used together in the vertical format. The immediacy of detail and unusual perspective (shooting down) bring the eye directly to the center of interest, the boy.

Advancing colors on the roofs of boats in the floating gardens of Xochimilco, Mexico illustrate how to focus selectively on a barrage of color. The focus here is on the bright foreground, using a 200mm lens. The resulting compression of the spatial planes adds to the impact of layered colors. Though the background colors are powerful, their smaller size relative to the more forward elements makes their presence a compositional aid.

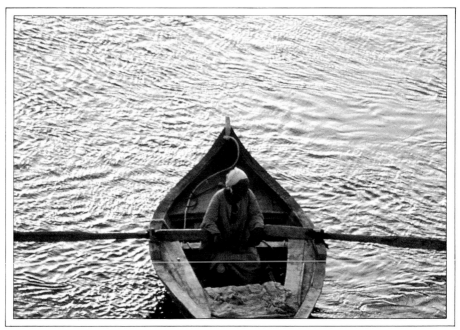

The ripples and currents of the Nile are vivid in texture as the side light skims across the surface of the water here. These patterns would have been invisible to the naked eye; only the angle of the light and the elevation of the camera render them so richly. The compressed look, resulting from the use of a 400mm lens with tripod, stacks the patterns upon each other, providing form and continuity.

atmospheric haze, objects seem to get lighter as they get farther away. Aerial perspective uses this phenomenon to create depth in the picture by differences in tone; objects appear darker or brighter in the foreground and get progressively lighter as they recede into the distance.

Aerial perspective is most apparent when the atmospheric conditions are less than crystal clear. Mist, fog, dust, or smoke create good separation of planes; so does the haze of early dawn, dusk, or an autumn day. A long-focus lens, which brings distant parts of the scene closer, enhances the effect of aerial perspective. On the other hand, wide-angle lenses are to be avoided in this situation. The composition may have to include a lot of sky, so be sure to compensate for the additional brightness when deciding on the exposure.

PATTERN

Looked at through the photographer's eye, the world is full of patterns—repetitious arrangements of lines, shapes, and colors. A composition utilizing pattern is generally harmonious and pleasing because it has rhythm and variety.

Filling the entire frame with a pattern is crucial for creating impact and order. A scene that seems chaotic from a distance may resolve into an orderly pattern as you close in and fill the frame with it. By isolating the pattern you emphasize it and give the impression that it continues indefinitely beyond the frame. The close-focusing ability of a wide-angle or macro lens is useful for getting in close and filling the frame with a pattern, while a telephoto lens can isolate a distant pattern and bring it in, or even create pattern by compressing distant elements together.

Small variations within a pattern will add interest. For example, a heap of apples would show a pattern of shapes made interesting by the variations in shape and color of each apple.

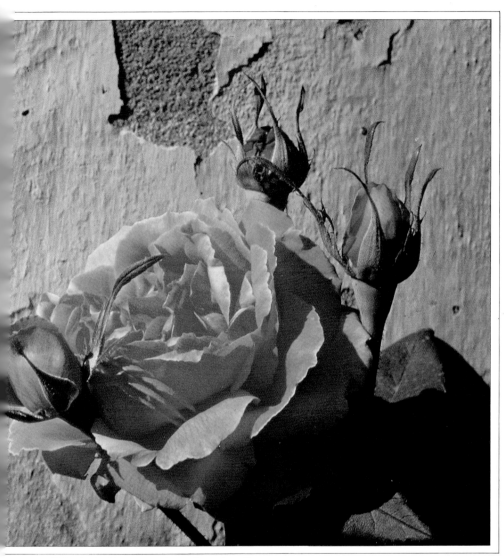

This shot of a rose and weathered wall
takes on a three-dimensional look because
the light serves to emphasize surface
detail. Side light is best for recording
texture; angular lighting can be used as
well but only if the subject has
three-dimensional features.

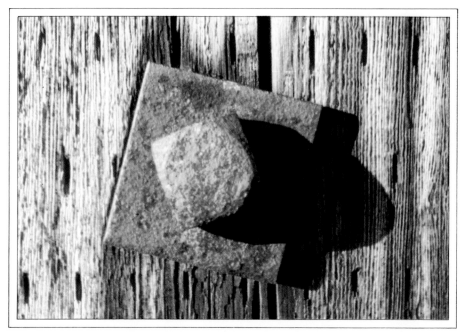

Late afternoon light emphasized the textures of this weathered wall with striated grain patterns and strong shadow detail. The rusted iron bolt and its brace were placed close to the center of the photograph to maximize the strong shadow balancing the picture on the left, while the square brace and its diagonal lines add compositional tension as the only nonvertical lines against a strongly vertical background. The round shape slightly off-center to the right is the point of focus. Ektachrome 64 was used with a 55mm micro lens, allowing accurate focus from close up.

Patterns are often most apparent when their two-dimensional quality is emphasized by a head-on camera angle and flat, even light. This is ideal for patterns that contain some inherent variety. Sometimes, however, more directional light or a shift in camera position to a somewhat oblique angle, or both, are needed to avoid monotony.

TEXTURE

Texture adds an extra dimension to a photograph. It conveys not only the visual aspects of the subject but its tactile aspects as well. The viewer receives a vivid impression of how the subject both looks and *feels*.

Close-up shots often reveal textures, especially in nature. Moving in close can allow you to bring out and emphasize the grain in a weathered piece of wood or the patterning of a leaf, for example.

Texture is pattern given depth. As with pattern, compose to fill the frame and look for subtle variations. For close work, a normal or macro lens is often best; wide-angles are good for capturing vistas. Telephotos are handy if you want to close in on a distant surface, but their compressing effect may compress the texture as well.

Light is crucial to texture. Directional light striking a surface at an angle brings the texture alive, creating shadows and reflections that point up the nature of the subject. Very rough surfaces are brought out well by obliquely directional but somewhat diffuse lighting. Smoother surfaces often need harsher, more directional light to accentuate their contrast.

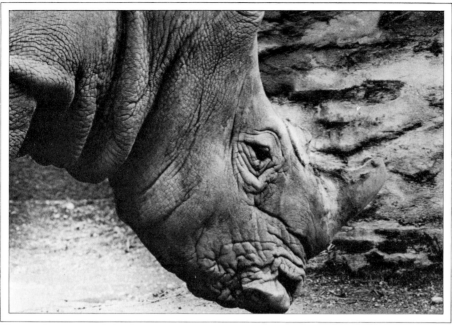

The rough textures of the rhino and the wall play off each other in this picture. The true feeling of depth was compacted and compressed by the tight cropping, the large image size, and a 300mm long telephoto lens.

Late afternoon sunlight slanting across a surface at a low angle is particularly suited to photographing texture; similar but weaker lighting is also given by early morning sunlight.

CREATING EMPHASIS

A photograph without a center of interest is confusing or even dull. Good composition uses a variety of techniques to attract the eye and direct it to the subject of the picture.

Depth of field. In composition, depth of field is invaluable. Control of depth of field saves many picture situations from being too busy, or prevents clashes in the colors and shapes of the background and foreground. Using depth of field, you can not only throw disturbing forms out of focus but also turn colors or shapes in the background or foreground into soft design elements. A portrait against a beautifully colored but busy

background, for example, can be simplified by using a shallow depth of field to focus just on the face, turning the background into a colored pattern.

Light. The use of light in composition as either a purely graphic component or as the main subject is another design element that presents itself from time to time. Shafts of white light alone can create interesting shapes. They can also be employed as visual cues to bring the eye to the center of interest, to spotlight a subject, or to separate spaces and indicate depth. Like the black, graphic density of a shadow, the abstract quality of pure white light adds another dimension to the composition. In a color photograph the inclusion of a pure white form adds impact, although its brilliance can overpower the rest of the photograph. It should be placed cautiously.

Framing. The use of frames within the picture is one of the simplest and most

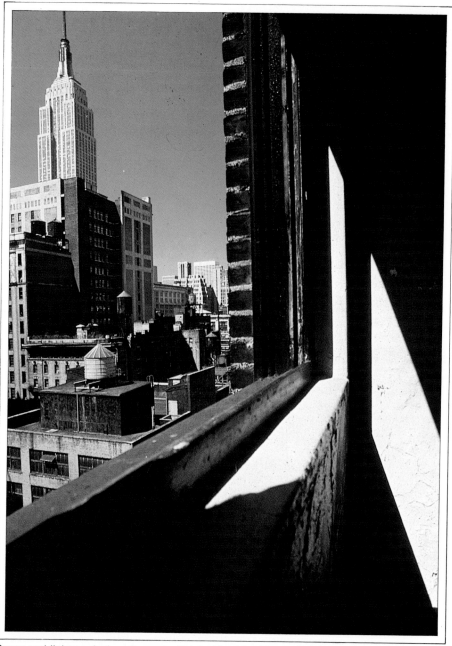

Space and light as design elements shape this shot. The bright white shape against a dark wall combines with the strong diagonal to command attention. The frame was split in half, with the window serving as a framing device and the strong vertical of the Empire State Building against the dark blue sky to balance the photograph. The use of a 21mm lens exaggerates the spatial relationships of the interior and exterior portions of the composition.

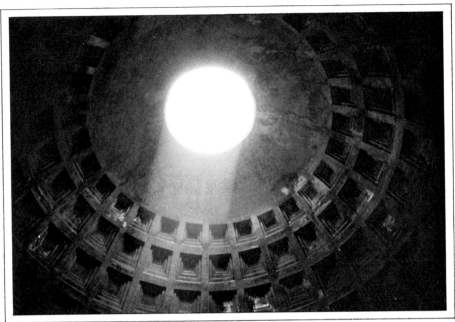

elegant solutions to the problem of emphasis. Find doors or windows or look for naturally occurring frames, such as trees or rocks, and use them to separate the subject, block out extraneous details, and create a sense of context. By including part of the windowsill in a picture of a scene through a window, for example, you can create balance and depth. For minimal detail in the frame, expose for the outside scene; for more detail, stop down to an exposure midway between indoors and outdoors. This technique works well with the subject silhouetted against a frame, allowing the photographer to tie foreground and background together into a unified composition.

REFLECTIVE SURFACES

Rain at night makes endless opportunities for using reflections, silhouettes, and abstract color forms that blend into one another photographically. The wet surfaces mirror neon and incandescent lights, bouncing their colors off the glassy surfaces. Commonplace subjects

Since ancient times the play of light has fascinated man, as can be seen by the open cupola in the dome of the Pantheon in Rome. The Sun, as it changed its position during the day, cast a moving shaft of light through the opening and onto the different statues that ring the rotunda. A 135mm lens and Tri-X film was used to capture the beam of light at midday; the light reading was taken from the upper dome with a one-degree spot meter.

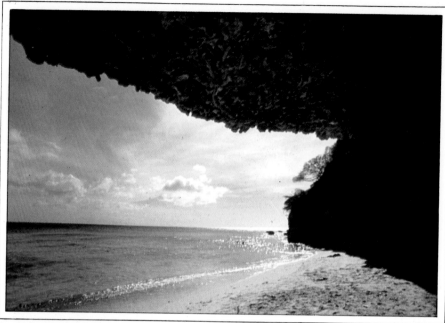

A coral cave was used as a framing element in this Caribbean beach scene. The lines of the horizon and shore make the appearance of depth and space between the cave's interior and the line of the horizon seem immense. The light brown colors of the cave's interior were important, so a balanced light reading of the wall and the sand was taken to show the interior detail.

Placement, texture, and the subtleties of gray gradations are the major ingredients of this shot of a pigeon in a window frame, taken in a small town in Crete. I used a 135mm lens and Tri-X film.

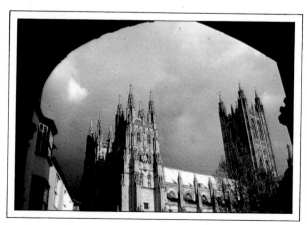

This photograph of Canterbury Cathedral uses a silhouette of the entrance arch and the surrounding buildings as a frame to create an interesting composition that dramatizes the massive shape of the cathedral still further. A 35mm lens and Kodachrome 25 were used.

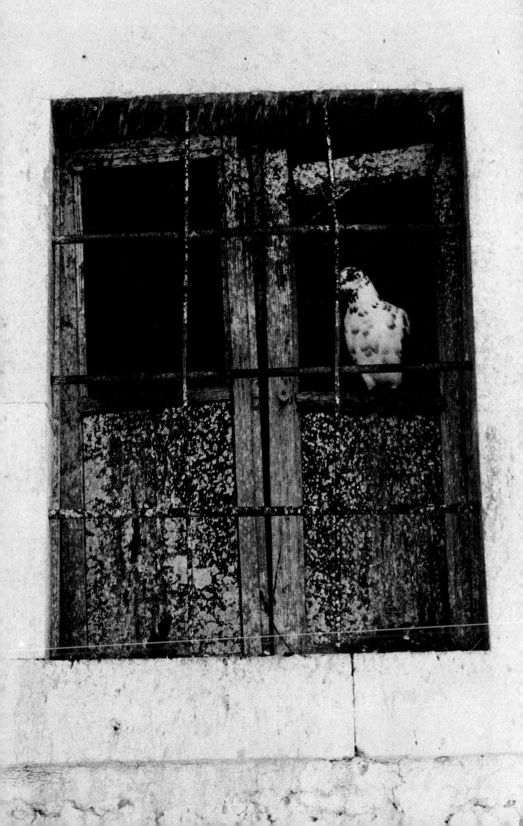

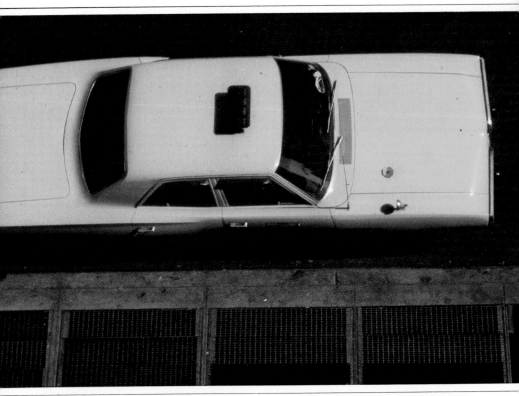

The New York City taxi with its deeply saturated yellow is a case of high reflectance off a metallic object, bringing the hue to its deepest color value. This was further intensified by a 1½-stop underexposure shot with a 180mm lens and Ektachrome 400 to accentuate the color. This type of light is the complete opposite of diffusion.

Rainy and overcast days bring out colors, as in this fishing village in Nova Scotia. I used a slow shutter speed, a 35mm lens, and Kodachrome 25.

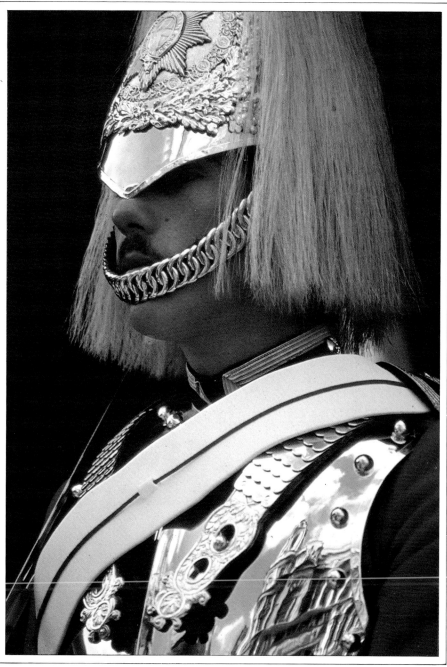

This Royal Guardsman with his brass breastplate illustrates a creative use of reflection. In this case the image is of a red double-decker bus in London. The light was overhead but the soldier was shaded by the awning of his sentry box; the exposure was made after a reading was taken from the general brightness of the subject.

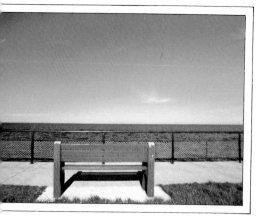

The high contrast of the orange bench against a predominant blue in this strong but simple shot causes some color vibration and acts as the color center of interest. The horizontal lines create a design order; the bench slightly off-center in the lower right breaks the background pattern and replaces it with color horizontals of its own. Advancing color is emphasized here. Taken on the St. Lawrence Seaway in Canada using a 35mm lens and Kodachrome 25, this photo benefited from a polarizing filter, which removed the water's surface highlights and saturated the blues.

take on dramatic new appearances, and ordinary streets and sights are magically transformed into mirrors of abstract interpretation.

Reflective surfaces in any photographic situation lend themselves to "photographer's eye" pictures: that is, photos made using a reflection for a well-thought-out reason, not just for the sake of shooting a mirror image. Metals or slick, polished surfaces open up another working area within the frame, a picture within a picture. Placing reflective surfaces into the composition calls for careful pre-photo thinking, since the novelty of two separate viewing planes can become confusing and disruptive. The direction of the light falling on the surface will influence the way the image appears. Each reflective surface is different, but a general rule of thumb is to use small apertures and work with the light behind you or to the side. Theoretically, this will cut down glare, but not always and not necessarily enough. If the subject is water, glass, polished wood, or the like, a polarizing screen will help remove reflections, particularly when the subject is at right angles to the sun. Unfortunately, polarizers don't work with polished metal surfaces, so try changing your angle instead. Reflections in water can be isolated and dif-

fused further by shooting through leaves at wide-open apertures to add a green color haze.

COLOR COMPOSITION

Color composition has no rules that cannot be stretched or broken to make a particular photographic point. A black cat can be effectively photographed even on the proverbial black background if there is a small, artistic touch of light to shape the picture. White-on-white abstracts or those with the lightest tinge of gray or shadow can create interesting results.

Some basic guidelines for the graphic use of color in a composition generally hold true (but are also open to artistic license). Certain colors, such as red, advance in the picture, while others, such as blue, recede. Viewing a scene may be easy or hard depending on the brightness and contrast of the main subject and its surroundings. If the background insistently pulls attention from the subject, the viewer will be confused and frustrated; if the subject and the background are in harmony, the viewer will immediately grasp the sense of the picture. Colors on the opposite poles of hot and cold, or at extremes in contrast, are hard to view because of the confusing vibrations they set up. Colors next to

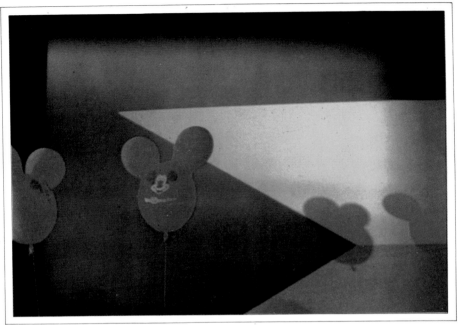

or close to one another on a color wheel, such as reds and oranges, are harmonious and pleasant to the eye.

Saturated colors (deep, pure hues) work well against unsaturated or pastel shades. Warm colors work well in foregrounds, with colder or deeper colors in the background and the coldest tones in the far distance. Bright or warm colors photographed against gray cause a sort of color radiation, making them appear as if they almost vibrate. Red on blue or vice versa causes a similar effect, because of the eye's inability to focus on both hues at the same time. Objects of contrasting and complementary colors should be of different sizes or focus in the composition. They are unequal in color saturation and will constantly compete for the viewer's attention if equal in importance in the picture. If, for example, two equally large objects, one blue and one yellow, dominate the picture, the viewer doesn't know which is more important, and is confused. The picture has no unity.

Shot in a Florida amusement park, this photo uses shadow as a key design element here; it has been placed to balance the brightness of the balloons. Had an exposure of one f-stop under been used, the shadows would have lost their detailed gray and become stark black shapes, changing the color structure of the photo and making it a picture that pulls back and forth for attention. The lens was a 90mm and the film was Kodachrome 25.

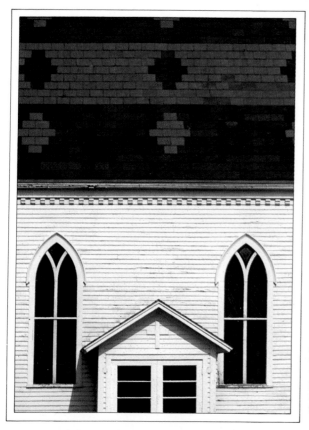

The same subject can be seen in two different graphic ways. I took several shots of this church, cropping differently and emphasizing different details. The vertical photo was taken with an 80–200mm zoom lens at the 200mm setting. The three main components were the deep blue sky, the white side of the building, and the neutral tile roof. The space in the photo was broken into three horizontal bars of color, all of different widths and color densities. The view is a narrow one that draws the viewer's eye to the white and black shapes at the base. The horizontal shot was made from the same working distance, with the lens set at 80mm. This view shows more of the church, since it is a horizontal shot with a shorter focal length. A completely new composition thus emerges. The basic formula of the three color bars still applies. Kodachrome 64 was used for both shots.

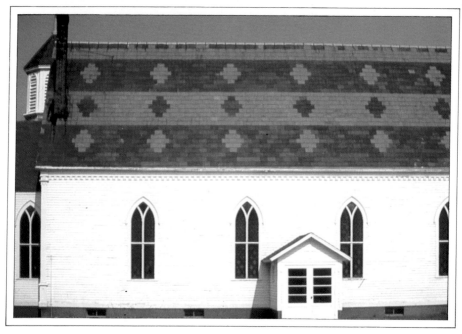

Sometimes advancing and receding colors appear together in nature, and the resulting interplay between the active and passive colors creates a special sort of visual tension. These flowers contain an array of highly chromatic pinks and reds set against neutral green leaves. Emphasizing the advancing effect is an overhead view, while selective focus keeps the closest flowers in focus and adds a three-dimensional quality to the final composition. Kodachrome 25 with a 50mm lens.

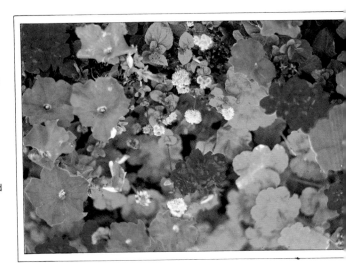

In any scheme where predominant colors are arranged in definite patterns, your angle of view and choice of lens are critical. The highlights of patterns are best shown by isolating them or changing the working distance to make the most of their unique graphic qualities. Brights and darks can be made to work together in virtually any scene by altering the graphic elements of the colors and the space they occupy. Compose and recompose in the viewfinder at different working distances, or change focal lengths to fill the frame.

A predominant background color, a deep blue sky, for example, will provide a very effective backdrop for any other color-subject that appears in the frame. People photographed in front of a red wall, children on green grass, or a white seagull against a blue sky all have one thing in common: the composition takes into consideration the power of the dominant color when composing the placement of the other subjects within the frame. People look better surrounded by warm or earth tones, but a tight head shot that fills the frame with a profile and a bright green or blue background also makes a dynamic picture.

Color harmony is achieved when closely related colors are combined — shades of red and orange, for example.

Harmony is useful for emphasizing the sameness of elements in a scene and creating a sense of unity. In composition, a color can be brought out by contrasting it with its complement. (Complementary or contrasting colors are those opposite each other in a color wheel. See Chapter 1.) A small area of red, for example, will seem more important if it is contrasted with an area of green, red's complement. Colors that clash can overwhelm a composition, drawing attention away from the center of interest. But used judiciously in combination with a simple composition, discordant colors can produce pictures with a great deal of impact.

Colors give definite emotional signals to the viewer, conditioned by his expectations. Red neon signs or car taillights, for example, create color reactions of varying degrees. Neon red draws immediate attention and thoughts of advertising; traffic red is observed for safety.

Since red is an aggressive color it commands our attention, but there are other colors and color combinations that have aggressive characteristics and are color signals as well. In the world of nature as well as the world of man, the colors yellow and black signal danger. Yellow can be seen from quite a distance as a distinct hue and is an "active" color. Red,

Abstract color detail and line are the design elements that make this red wall in New York City a study in the power of aggressive color. The composition is made up of seven blocks of color and space. The red walls frame the photo on each end and push out the white on the window. White is a naturally advancing color, but the red walls and black opening underneath make it equal to the reds because it covers the largest space.

orange, and yellow are in fact the three most active and "hot" colors, which advance toward the viewer even at great distances, a quality that can be used in color photography to make instant impact and to draw the eye.

The colors that are known as "passive" and "cool" have their own inherent qualities. Blue, for example, suggests reticence and passivity. In a color composition, blue is one of the receding or withdrawing colors (green, violet, and blue-green are others). The passive aspects of blue suggest mood and reflection. It is a cold color and at its deepest can be used to suggest melancholy and symbolize isolation. Alternatively, as a bright color of nature, the blue of skies and seas often symbolize light and life. A subject that appears in a blue twilight or a dimly lit blue landscape will seem quiet and subdued.

The neutral colors—green, green-yellow, magenta, gray, and brown—serve as harmonious and noncompetitive design components that will not distract the eye from the color composition of the picture.

In color composition, the visual sensitivity of the photographer is the determining factor in what will make a dynamic, well-balanced photograph. But in the course of your picture-taking, care-

ful selection of what colors to include is essential. In scenes that are highly graphic or where the colors are in disarray, you have to create a worthwhile picture from confusing color elements. Zone in on a small area by compacting the photograph, using a selective angle of coverage.

Conversely, harmonious tones and shapes that do not vie for attention can be equally balanced throughout the shot. Blocks of color and geometric shapes can be used to make a photograph with balance and visual interest. Think of a picture as pieces of a puzzle, and move the camera across the subject area until you find an equal balance.

When working in areas partially affected by filtered light or in areas where there is one dominant color, you must be aware of the overall color tonality of the light. Color casts are not bad in themselves; appreciate and use them, rather than trying to avoid or filter them out. Be aware of the interplay of light on an object and how that can be used to isolate a subject from the rest of the environment. White light streaming through an open window or door will bring direct light into an area of color. However, the amount of white light and the area it covers in the scene will counterbalance the intrinsic color of the scene. In this

Lines and color work together to create a pure graphic picture of this wooden bridge and its reflection. A covered bridge over a stream may suggest the rustic, but when it is seen as a compositional design where light and dark play together in the reflection, the subject almost becomes secondary, and the strips of color in the scene are what first catch the eye. This was taken on Kodachrome 25.

sort of situation the light-value-color relationship must be carefully balanced by the photographer when he is composing the shot.

When you are photographing in extremely bright conditions or mixed high-contrast situations, there is just one general rule for color composition. The eye always reacts to either the brightest or the whitest form in any given scene because of the strong visual impact made by the high intensity of the color. The strong brightness of any shape or form must be made to work for the final composition, not against it, so that its power and weight don't overwhelm the rest of the picture. In the picture on page 61, for example, the white areas are used to frame the composition. View and re-view the scene through the lens, waiting for the correct balance of shapes and forms.

Manipulating color intensity by slight under- or overexposure gives you some leverage when working with transparency films. One rule of thumb that applies with any underexposure is that the color

saturation and contrast are immediately increased and shadow detail is lost, while overexposure can give a lighter, more pastellike feeling. The "white" light that affects the film lightens the colors, opens up shadow detail, and sometimes can create lighting effects that you could not see while taking the picture. To capture shadow detail in an overall sunny environment, the balance of the scene can be best recorded by slight overexposures that still reproduce acceptable accuracy in both the sunlight and shadows. Color print film has more latitude than slide film, so you must over- or underexpose more to get similar effects. Overexposure is preferable, though; too much detail can be lost in an underexposed color print.

Good composition has no guaranteed techniques or certain solutions: even the simple guidelines discussed here are valueless unless applied in conjunction with a photographer's eye. It is up to you to realize that every photographic situation is different, and that each calls for its own solution.

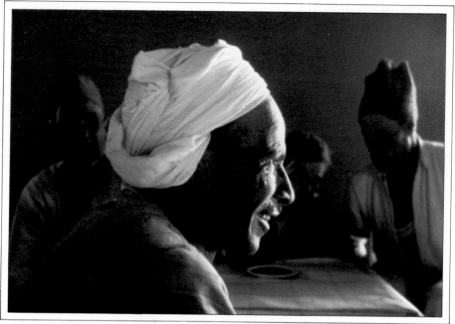

Inside this Egyptian tent a red cast over the entire scene resulted from the bright overhead sun passing through the translucent material of the tent and creating an even distribution of diffused, filtered light. The door of the tent was opened slightly, sending in a direct beam of unfiltered white light. The man in the foreground was most strongly affected by the narrow beam of light; his outline took on the distinctive white cast, isolating him from the men in the background. The light reading was off the face of the man in the foreground; an 85mm lens was used with Ektachrome 400.

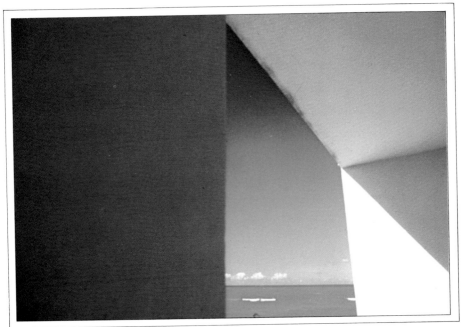

Bright scenes with strong contrasts must be carefully exposed. For this scene in Puerto Rico, a polarizing screen was placed over the lens, and meter readings taken of the darker wall to the left and of the overall bright areas. An in-between exposure of f/5.6 at 1/125 second was used with Kodachrome 25. The polarizing screen reduced the light by about one stop.

3
Film and Color Techniques

THE DESIGN AND CONSTRUCTION OF THE modern 35mm single lens reflex camera are the result of nearly two centuries of concerted effort to find ways to record light on film efficiently and accurately, using a portable camera. The scientists and artists who contributed to the development of modern photography have given us a medium of unsurpassed immediacy and unlimited potential.

COLOR TEMPERATURE

The photographer must be aware of actual color differences among apparently similar forms of white light. The light of the sun at dawn or sunset, for example, is reddish; at high noon, it has a high proportion of blue in it. Indoors, tungsten and fluorescent lights have their particular color qualities. The problem for the photographer, then, is to find a way of recording color accurately. To do this, a basic understanding of the concept of color temperature is needed.

When a substance (for example, the filament of a lightbulb) is heated, its color changes as it gets hotter, glowing first red, then orange, yellow, white, and finally blue. Color temperature is a measure of the color, not the actual heat, of the light emitted and is measured on a scale calibrated in degrees Kelvin. The sun at high noon measures 5,500° Kelvin, and is the standard for white light. At dawn or sunset, sunlight contains more red wavelengths and has a color temperature of roughly 2,000° K. At high noon on a reflective beach or at high altitudes, the color temperature may be as high as 10,000° K or more, giving a distinct bluish cast to the shadows. Indoor lighting with standard tungsten lightbulbs has a color temperature of about 2,000° K.

COLOR FILM

Color film falls into two categories: color negative (print) and color transparency (slide). Color negative films have their virtues, among them the ability to make multiple prints from the negative. On the other hand, color negative films are expensive to buy and process, and the prints will fade. More importantly from the serious photographer's point of view, color prints cannot be reproduced well in magazines, books, and so on. Color photographs for reproduction must almost always be on transparency film; and except for certain specialized purposes, slide film is the choice of the professional. Throughout this book, it is assumed that color transparency film is being used.

Within the category of color transparency films, the photographer has the choice of daylight (Type A) or tungsten (Type B) films. This is because the wide variations of color temperatures from various light sources is more than any one photographic emulsion can handle. **Daylight films.** Daylight films are designed to give accurate color when used with sunlight or with flash. Among professionals, Kodachrome 25 (ASA 25) and Kodachrome 64 (ASA 64) are the

To shoot this desert valley in Mexico, tungsten film (Ektachrome 160) was used with a 35mm lens to make a daylight scene appear to be a moonlight time exposure. In fact, the exposure was average for mid-afternoon, and the tranquil blue hue that suggests a desert night is the result of how tungsten film is balanced for studio lighting: cold colors are emphasized and whites have a bluish tinge, since daylight has more blue and less red than studio lights.

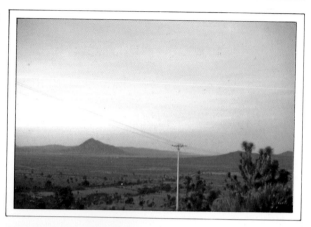

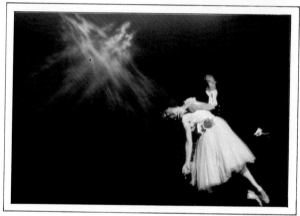

Tungsten film is designed to reproduce "accurate" color under spotlights like those in a theater. For this shot, a light reading was taken off the ballerina's face using a one-degree spotmeter, and a rangefinder camera with a 50mm lens was used to capture a quiet scene of *La Sylphide.*

films of choice, giving excellent color rendition, high resolution, and fine grain. Ektachrome 64 (ASA 64) is similar to Kodachrome 64, but with slightly more grain. Ektachrome 200 (ASA 200) and Ektachrome 400 (ASA 400) are faster versions of Ektachrome 64, with slightly higher contrast and grain. Another group of commonly used films is Agfachrome 50S (ASA 50), Agfachrome CT 18 (ASA 50), and Agfachrome CT 21 (ASA 100). These films tend to be grainier and more contrasty, and give excellent saturation of red tones. Fujichrome 100 (ASA 100) and Fujichrome 400 (ASA 400) are also somewhat grainy and high in contrast, and reproduce greens and blues well.

Tungsten films. The tungsten-balanced equivalent of Kodachrome 64 is Ektachrome 50 (ASA 50), a film that is particularly good for long exposures. Ektachrome 160 (ASA 160) is the tungsten equivalent of Ektachrome 200. Agfachrome 50L (ASA 50) is the tungsten equivalent of Agfachrome 50S.

Different brands of film have different characteristics. Which you choose to use depend on personal preference and sometimes on geographical location. Kodak, Agfa, and Fuji films are available worldwide. In the United States and Canada, Kodak film is ubiquitous, and can be purchased and processed quickly almost anywhere. Agfa and Fuji films must usually be mailed to a central proc-

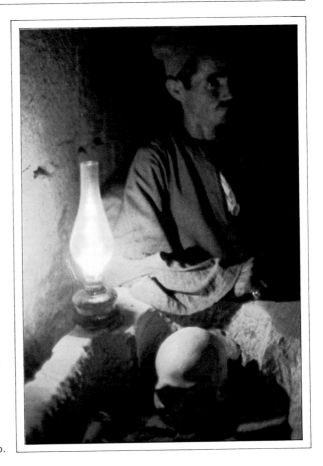

Daylight film used in artificial light, whether electric or an oil lamp, will produce the warm oranges and earth tones that wash over this Egyptian tomb. Ektachrome 400 was used with a 35mm lens and a hand-held exposure of a half-second to photograph the ancient mummy and his guardian. Because of the extremely low light levels, the through-the-lens light reading was taken off the man in order to gain as much detail as possible in the darker parts of the tomb.

essing point. Agfa films are more popular in Europe, and processing is quite easy to obtain. Fuji films are most widely used in Japan and throughout the Far East.

Other brands of film, such as Sakura or private brands, are also available, but use them with caution the first few times. It's best never to use an unfamiliar brand for important shots unless you're desperate.

Generally speaking, the resolution of a slow film is higher and its inherent grain structure finer than that of faster films; its design allows it to reproduce very fine detail. As a rule, the best film to choose is the slowest film that is still fast enough to do a technically superior job. The clarity and sharpness that are evident in the successful photograph are not only the result of the characteristics of the particular film stock but extend to a combination of mechanical and human elements such as the quality of the lens, the accuracy of focusing, the speed of the shutter, the diaphragm opening, and, most importantly, the steadiness of the photographer and the camera during the exposure.

Daylight film used indoors, under tungsten lights and without corrective filters, will give a warm orange glow to the scene. If you don't want that effect, use a blue filter such as 80B to balance the film for tungsten light. Conversely, using tungsten film outdoors will give

the scene a distinct bluish cast. Although the glow of daylight film indoors is often acceptable to the eye, tungsten film outdoors is generally perceived as quite unnatural. Use an 85A amber filter to warm up the light.

If you don't have or don't want to use color-balancing filters, you can get a similar effect just by modifying the exposure. For example, an increase in exposure of one-half to one full stop will heighten the color cast, while a decrease in exposure of one-half to one full stop will lighten the false color and neutralize the overall color shift.

Mixed light. What film should you use under mixed lighting? If the mixture is tungsten and daylight, estimate which is predominant and choose your film accordingly. Fluorescent lights are tricky, because different brands have different color temperatures. In general, fluorescent light has a greenish color to it, so try daylight film with a CC30 magenta filter. Mixed tungsten and fluorescent light is a real headache. Rather than trying to filter, compromise by using daylight film. Mercury vapor lights, often found in factories and sports arenas, can give a blue-green cast that is difficult to correct, but try daylight film with a CC20 or CC40 red filter. A common form of highway and parking-lot light is sodium vapor lamps, which have an orange-yellow color; daylight film with a CC20 or CC40 blue filter may do the trick. With mixed vapor lighting, correct for whichever light source is predominant. Many sports arenas are lit with carbon-arc lamps, which allow you to use daylight film, since carbon-arc light is actually very close to daylight in color temperature.

RECIPROCITY FAILURE

Theoretically, film exposure equals the light intensity multiplied by the exposure time. In other words, an exposure of 1/125 second at $f/4$ is the equivalent of an exposure of 1/60 second at $f/5.6$. However, if the exposure is longer than about one-quarter of a second, this equation no longer holds true with most color films. Unless an exposure compensation is made, the shot may have a color cast, often tending toward green or yellow, because the different emulsion layers of the film react differently to long exposure. Since tungsten-balanced films are designed for slower speeds, reciprocity failure is less of a problem with them.

Suggestions for reciprocity failure correction are included with the instructions for each roll of film. Generally, correction involves a combination of increased exposure and filtration, and varies among films.

The capabilities and color of the film, as well as the type of transparency it will produce, can be changed by pushing it, which is done by increasing the ASA setting of the camera beyond the ASA of the film. How much the film is affected will depend on how far it is pushed. Kodachrome cannot be pushed because its processing is a very complex procedure, but Ektachrome film, developed by Kodak Process E–6, can be pushed as much as two stops. The advantage of pushing film is that it permits the photographer to work under any existing lighting conditions, whether hand-held low-light levels or tripod time-exposures or fill-in flash night scenes.

The main characteristics of pushing color film, other than the speed factor, are an increase in grain, a visible color shift (Ektachrome tends to shift toward yellow), a loss of dimension (color will sometimes appear flat, but not under mixed lighting conditions), a change in the contrast of the scene, a total altering of the film's ability to respond accurately to variations in brightness within the scene, and a softening of detail in the hot spots of light. Grain in many cases will make a better or more graphic

Reciprocity failure is clearly illustrated in this shot of a gondolier in Venice. The blue-purples of late evening mixed with Ektachrome 64 pushed to ASA 250. The film's inability to respond normally at the slow shutter speed brought out the cool purples and blues and recorded them in a way the eye does not see. The lens was a 105mm telephoto.

A fence and town in southern Spain were transformed by shooting them through a very wide-angle lens on infrared film. The green sky is disorienting, the red grass unnatural, the angle of view disconcerting. A number 15 yellow filter was used, and a bracketed exposure of one stop under the light reading was selected. All that could be certain was the angle of view; the color was the whim of the film's response to that day's light.

What appears to be a moonrise over the gigantic monuments at Abu-Simbel in Egypt, bathed in deep blue, displays the superior texture qualities of infrared film. The shot was actually made at high noon in an extremely hot and arid area, and so the infrared film obviously had much to do with the color. A very wide-angle lens was used to exaggerate the perspective and produce the white burst of lens flare that is interpreted as a ''moon.''

rendition of certain types of mixed light or dramatically lit events such as concerts, carnivals and fairs, interiors, and night scenes.

A basic rule of thumb to remember when over- or underexposing film for aesthetic reasons is that the white light allowed to reach the film will turn colors to tints and pastels, producing lighter and less contrasty hues. White light mixing with color will overwhelm the original color and produce a desaturated "new" color. On the other hand, an underexposure will reduce the light and add shades to a hue, producing colors that are saturated to their deepest possible hue. The amount of under- or overexposure will determine the response of the film to the original color.

INFRARED FILM

In the visible spectrum our eyes can see and adapt to color situations and changes better than film can, but color film for that matter can see and record colors and motions our eyes cannot. When we leave the visible light spectrum by working with infrared color film, we cross over to unpredictable color, invisible to our eyes but recordable on a special film as startling color displays. Infrared radiation, made up of wavelengths longer than those of visible red light, is an invisible world of radiant energy that is felt as heat in everyday life. No trichromatic film can pick up its wavelength, since conventional film is sensitized to the wavelengths for blue, green, and red only. Since infrared film is sensitized to green, red, and infrared wavelengths, it records a positive yellow image in the green layer, magenta in the red layer, and cyan in the infrared layer. Every substance has a particular infrared reflectance level. For example, green foliage tends to record as a magenta-red when in good health, but is seen as a purple if there is disease present. That living and inorganic substances reflect different values and colors makes the use of infrared film indispensable in military reconnaissance (it was designed for wartime use), weather and pollution observance, and satellite and astronomical measurements and photography.

Infrared film is supersensitive to heat; that element alone can change the recorded image drastically from hour to hour. An infrared photograph shot at high noon, for instance, will be totally different in color than one taken several hours later in cooler, less intense light.

An important aspect in the use of infrared is the pollution factor of the particular locale. Since infrared wavelengths are longer than visible light waves, they tend to bend and scatter less, and thus have a greater effect on the film's ultimate color rendition. Long exposures change color drastically, as do mixed-light situations. There is no absolute predictability to the color responses that are going to be picked up by the film.

Since infrared film is not designed to record blue light in any of its emulsion layers, the usual yellow filter layer of conventional film to screen out extraneous blue light is not present. To compensate for this, it is advisable to use a yellow filter on your lens when shooting with infrared. A number 12 or 15 yellow filter is recommended for general use regardless of the light source. Of course, for totally unforeseeable results, any color filter can be experimented with. Deep reds, greens, polarizing screens, and specialty filters all provide areas of total unpredictability and nuance when used in conjunction with infrared color transparency film.

The exposure latitude of infrared film is limited and erratic, so several exposures of each frame should be made at one-half to one full f-stop in either direction. Some photographers rate the film at ASA 100 (the recommended speed); others rate it at 200. In either

The man with the bicycle was taken in open shade with infrared film and no filter. The skin tones are surreal, cold and greenish; the tonalities are very close throughout the scene because the film is ultrasensitive to the blue-light cast of the open shade. The man and the bicycle are recognizable as forms, the wall and the cobblestones are realistic, the color is impressionistic and free. The light reading was taken off the man with a through-the-lens meter and an 85mm lens.

case, bracketing is absolutely essential.

Since infrared wavelengths are much longer than those of visible light, you cannot focus normally and some correction is needed. Many lenses have a red mark on their barrels for this purpose. Line the focusing scale up with the mark; the image will appear out of focus in the viewfinder, but will be in focus to the film. A somewhat rougher way of accomplishing the same thing is to open the aperture as wide as possible, focus normally, and then focus closer until the image just begins to blur. Again, the image will be out of focus to the eye, but will be in focus to the film.

EXPOSURE METERS

The modern single-lens reflex camera is made up of many intricate subsystems designed to make a sophisticated, highly tuned unit. Within this advanced mechanical complex, the modern viewing system is perhaps the single most important achievement as far as the photographer is concerned, because it allows him to view the subject with considerable accuracy. The optical control center for the operation of the camera is designed to interact with the lens and produce an accurate visual rendition of the subject as it will appear on film. In a real sense, then, the brain work of photography takes place on the viewing screen.

The other major component in the camera housing is the through-the-lens (TTL) exposure metering system. Most cameras today contain well-designed, sophisticated light meters that are in actuality minicomputers programmed for reactions and readings. The light meter, no matter what type it is, can

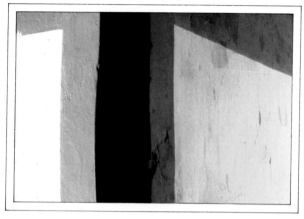

This abstract photo of a wall corner in Portugal is a living gray card. The open shade and harmonious tones provide the rare "average" color scene. A white card placed in this scene would appear white. The light reading was a general measurement of the overall subject; a 35mm lens and Kodachrome 25 were used.

A freshly painted wall among the glass buildings in Manhattan acted as a white card here. The problem was to keep the wall a brilliant white; the solution was to deliberately overexpose. A spot reading of just the white wall would have fooled the meter into an underexposure. Instead, to balance the high and low ranges, the reading was taken off the medium tones on an overcast day. A 200mm lens was used with Kodachrome 64.

The use of white light can be controlled through underexposure when working with an isolated brighter-than-average subject, such as this white marble bust of Augustus Caesar. An underexposure of two f-stops brought out the features of the face and darkened the distracting background into a dense black that enhanced the richness of the main white subject. A 50mm lens and Kodachrome 25 were used.

only get you to the point of a mathematical light evaluation of any particular scene; it cannot determine the way to use the exposure for a beautiful vision of the subject.

Modern through-the-lens meters fall into three categories: averaging, spot-reading, and center-weighted. Averaging meters view the entire scene and give all parts equal weight in the equation; they will thus indicate an exposure based on the average illumination over the whole picture area. Spot-reading meters look at just a small part of the scene, usually the part centered in the viewfinder, and indicate exposure based on the illumination of that area. Center-weighted meters, probably the most common today, are a compromise between averaging and spot-reading meters. They read the center of the scene, but also average in the edges, resulting in fairly accurate exposures under most conditions. Check your camera manual for specifics on your camera's particular system. In general, when using TTL meters, decide what part of the scene is the most important in terms of exposure and place that part in the area of the viewfinder where the meter will read it with the most accuracy.

Light meters are designed to give correct exposures of *average* situations. Since the average reflectance level of any given scene, indoors or out, is 18 percent of the light falling on it, the meter will render situations as equals whether they actually are equal in reflectance or not.

The calibration of light meters to read a general 18-percent reflectance of any so-called "average" brightness situation usually works well in the area of medium-range exposures. However, scenes of extreme brightness or darkness, as well as those with backlight and specular highlights, are read by the meter as "normal" in reflectance values, so that the visually and technically "correct" exposures of a photograph may not be the same. An exposure reading off bright white snow on a sunny afternoon, for instance, will give you a recommended exposure that will be considerably different from what you have observed with your eye. You see bright white snow; the meter sees 18-percent gray snow, and renders an underexposure of the scene. Conversely, a close-up light reading off the face of a black cat will give a reading that sees the subject as a dark gray cat, suggesting an exposure that does not sufficiently compensate for the darkness of the subject. Regardless of the type of light meter you are using, the most important factor to be considered when determining exposure is a careful reading of the subject area.

A good way to turn the through-the-lens metering system of your camera into a more sensitive instrument is to attach the longest telephoto lens you have to the camera body and zone in on the precise area to be measured. This is a sharp fine-tuning of the metering capabilities of your camera system and is a safeguard against miscalculations because of distance.

Another alternative metering technique for dealing with distance or scattered lighting conditions is to locate an object of area that has the same type of light falling on it as your subject and therefore will have a close relationship to the amount of light reflectance of the main subject. This type of reading substitutes a related but less complex lighting situation. For special problems, such as glare from ice and snow, bright beach and desert scenes, or heavy, overcast days, use the palm of your hand as an 18-percent gray card. Your palm will reflect about twice as much light as a gray card, and assuming that it is in the same light as your subject, you can take a reading off it and then open the lens up one additional full stop to make up the difference in exposure.

Bracketing your exposure is best in

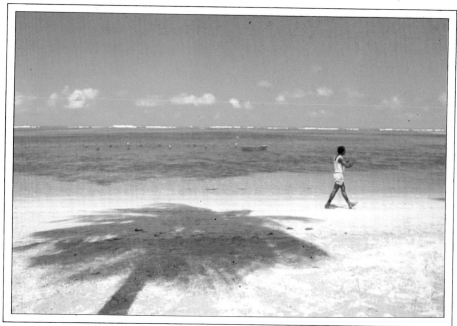

In this photo, shot with a 35mm lens and Kodachrome 25, the bright open light of Puerto Rico is reflected by the sand, which acts as a reflecting source for the evenness of the overall exposure. Several readings were taken of the sky, the shadow of the tree, and the sand itself, and an average compensation made. Since shadow detail of the palm tree is an important part of this scene, the exposure was carefully controlled. An underexposure would have rendered the sandy beach darker than it originally appeared.

difficult exposure situations. For any type of tricky light, bracketing exposures provides even the most knowledgeable professional with the security of knowing that the ones that didn't work can be edited out.

METERING TECHNIQUES

When the scene is not an average lighting situation, exposure meters will give misleading exposure indications; and it is here that the photographer's understanding of light becomes crucial.

Reflective situations. As explained above, most meters average the light on the subject. Unfortunately, in a highly reflective situation, such as a beach, snow, or sun on water, this will lead to underexposure as the meter overcompensates for the additional light. Increase the exposure by one or two stops to correct for this. Back lighting, as well as strong cross lighting, add a new dimension to

any scene where water is a dominant part of the picture. The intense "hot spots," or specular reflections created by this type of light, will make the meter tend toward underexposure. When deliberately used as a source, light readings of the specular highlights will produce dramatic underexposures of high contrast, bringing out the glistening patterns of the water.

Back lighting. Many photographers end up with unintentional silhouettes when photographing against the sky. Any bright background will confuse the meter, leading to an underexposure. In this sort of situation, get close to the subject and take a reading excluding the sky. If you can't get close, try opening up a stop and a half.

When shadow detail is not an important factor in the photograph and form and shape are the primary considerations, you could decide on a deliberate

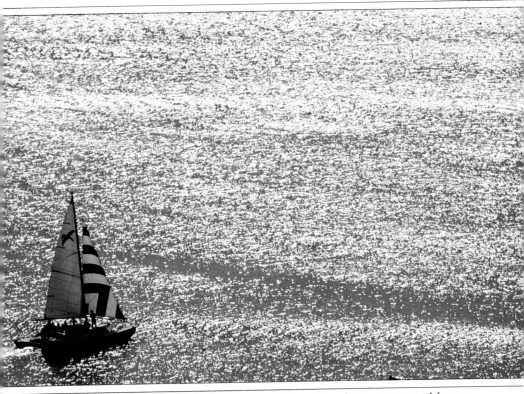

silhouette by an underexposure of from one-half to three stops. This works best when there is a contrast between a dark subject and a light background.

Back lighting is usually strong and direct, yet it can be made to generate gentle, almost mystical effects by opening the lens up and letting in white light. The dramatic effects can be stunning when shadows and contrasts appear: the smallest reflections seem like sparkling gems, lines and forms are ominous, and flare effects from the lens facing the light directly heighten the graphic impact of the picture.

Strong back light is best for close-ups of people and objects where no highlight details are important. Opening the lens up two full f-stops will allow four times the amount of white light to reach the film and will lighten the colors into placid pastels, adding an overall halo effect to the scene. Halo rim effects, or rim

This sailboat is on an ocean of frozen highlights that the eye could not see in the original view. The meter reading was taken directly off the water and the exposure was opened one full stop to avoid underexposure. The suggested meter reading would have rendered the sailboat a virtual silhouette and the patterns of water would have been too dark. If the sailboat were closer or the highlights larger, an additional overexposure would have been necessary, but because in this case the highlights were small and scattered, only one stop over was needed. I used a 300mm lens and Kodachrome 64.

lighting, caused by a strong light directly behind the subject, add a three-dimensional quality to the picture. The added white light around the edges of the subject separate it from its background. In general, back lighting provides middle tones in color; shadow details retain their pastel hues. Back lighting brings out the best in transparent or translucent subjects such as flowers, clothes, and lace, as well as all types of colored glass, stained windows, and gems. When taking close-ups of details of stained glass or similar translucent subjects, meter directly off the subject for the initial exposure. Then open up one-half to one full f-stop for the next exposure. One of these bracketed shots will give a vivid recording of the colors.

Side lighting. Back-lit and side-lit subjects usually require more exposure than those that are front-lit. In general, an overexposure of one-half to one full f-stop will give the best results in a medium-distance side-lit shot. An overexposure of one to one and a half stops over the indicated reading is best for side-lit scenes if it is important to preserve shadow details and keep a balance in the colors.

Contrasting backgrounds. When a background is much brighter or darker than the subject, exposure compensation is usually needed. Just the same as with a back-lit subject, move in close and meter just for the subject, excluding the background. With scenes containing large areas of light and dark, a compromise exposure is usually best. Meter the bright area, meter the shadows, and choose an exposure in between.

EXPOSURE IN POOR LIGHT

In dim light, such as twilight or badly lit interiors, focus and exposure are difficult. There are a couple of good techniques for focusing. One way is to estimate the distance to the subject and use the distance scale on the lens barrel

for focusing. Alternatively, focus on a bright object at about the same distance as the actual subject, and then redirect the camera. It is usually easier to focus in dim light using a microprism focusing screen.

Determining your exposure is harder. It helps to use a fast film with a wide-angle or fast normal lens, and to be prepared for long exposures with tripod and cable release. If you can't get the meter to give an indication, even at the slowest shutter speed, try doubling the ASA setting until you get a reading. Increase the exposure by the equivalent number of f-stops; then set the ASA back to its original position. Remember that reciprocity failure will be a problem with long exposures, and always bracket your shots.

Shots of bright street signs and lights can usually be hand-held. Use daylight film if there are a lot of neon lights. If the subject is a single area of light against a dark background—a floodlit building against a dark sky, for example —expose just for this key area of light. Flames can be captured using daylight film and whatever exposure the meter indicates. Use the fastest possible shutter speed, and try to resist the temptation to overexpose.

For poorly lit interiors, flash is often the suggested solution. Entire books have been written on the subject, and it makes no real sense to discuss it here. Flash units are disruptive, and even when used well often give unnatural results. If you understand your film and camera, develop a steady hand for long exposures, and learn to take advantage of what light there is, you will get fine pictures without flash, even when the light seems marginal.

SHUTTER SPEEDS

In the realm of time and space, photography takes its leave from the world of exact seeing. Action is recorded in

These boats, taken in late afternoon light in Rhodes, are an example of the special interaction of light and water. The undulating wavelike reflections occur when the lightwaves pass through the water, interact with particles there, and then reflect back up from the bottom. The shot was taken with a 135mm lens on Fujichrome 100.

frames of color and movement that the eye could never see at the time the exposure was made. The mechanics of the camera are the tools that record this unseen world, where action can be stopped at thousandths of a second or slowed down to light tracks that trace the trajectory of luminous objects. It is the choice of the photographer whether a speeding train is recorded as a gleaming chrome blur or stopped cold and isolated in sharp, precise detail. Both of these photographic capabilities are beyond the capacity of the eye to observe when they actually occur, yet both images are acceptable illustrations of motion.

Since the shutter speed controls the time that an amount of light reaches the film, variations of these speeds will bring mechanical creativity into use. The guidelines discussed below and the extending and breaking of them are all

relative. The point is that the use of time as a critical element in the photograph is an effective force.

Stopping motion. The three main factors to be considered when attempting to freeze the action in a photograph are the speed of the moving object, its angle of direction to the camera, and its distance from the camera. Although there are no set formulas, by varying these elements in relation to one another you can achieve special effects.

The faster the speed of a moving object, the faster the shutter speed needed to stop the action. A slow shutter speed will, for example, show a rapidly moving object as an indistinguishable blur. Observe the subject, its movements and behavior, and be alert to those times when the actions of the subject will define best the essence of its activity. Proof of motion in the photograph depends on how realistic the action taking place

The looming monoliths of Stonehenge here become black shapes used for graphic impact. The bright clouds were the basis for the meter reading; an underexposure of one f-stop was used to further saturate the sky and clouds while removing detail from the ancient structure. A 21mm lens and Kodachrome 25 were used.

appears. Some pictures fail because the shutter speed used and the particular movement picked to exemplify the event were stiff and badly posed. The impression of speed even while stopping the action is the key to a successful "stop motion" photograph. For instance, if a race car that is traveling at two hundred miles an hour appears in the photograph to be parked at the racetrack, the purpose of stopping motion has been defeated. If, on the other hand, movement is shown in the background, if the photograph is a panning shot, or if there is noticeable motion in some part of the car, the impression of speed is better conveyed.

Panning is frequently used to retain

Playing over the antique furniture in this interior scene in Holland is diffused white light from the window. Since the color of the room was a warm golden yellow, the white light mixed with the room colors to create an even blend of color and light balance. The light is high and comes in at an angle, so the objects in the room are highly sculpted and the gradations of shadow detail are evident. The scene was photographed with a 35mm lens and Kodachrome 64, and the reading was off the tones of the ochre-colored wall.

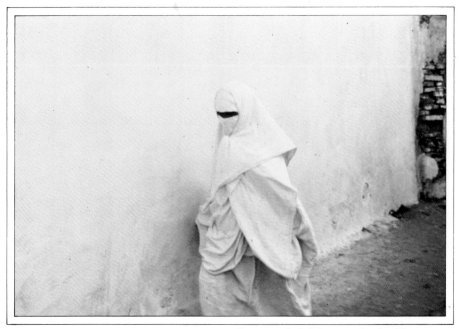

Extremes in brightness play in this photograph taken in a casbah in Morocco with a 35mm lens and Ektachrome 400. The white walls were rendered an accurate white by taking the light reading off the brown dirt. Dirt can act as a substitute gray card, since it reflects 18 to 20 percent of the light falling on it. Here the result was a light reading one stop over the recommended meter reading. The slight beige tint on the wall is the reflection of the brown ground, the dominant dark color. This white on white is on the extreme end of the film's ability to record detail. Another half or full stop overexposure would have made a washed-out picture; the delicate balances between the whites and light browns would have been lost.

with accuracy the sharpness of the main subject relative to the background. Because of the moving camera, the background becomes a color blur, adding to the impression of motion. This happens because the camera is moved in an arc following the subject, reducing the relative speed at which the subject passes before the camera and blurring the unmoving background. The slower the shutter speed is, the greater the blur will be; the closer you are to a moving subject, the faster the shutter speed you will need to freeze the motion. Look for situations where the lighting will not change sharply and cause an incorrect exposure as you pan.

A basic rule relates shutter speeds and the focal length of the lens being used. For most recommended exposures, the lowest shutter speed to be used (in theory) should reciprocate the focal length of the lens. For example, a 500mm lens should be hand-held at least at 1/500 second to avoid any camera shake and get a steady picture of the subject; 1/30

A slow shutter speed of ⅛ second was used with a 35mm lens and Fujichrome to capture the woman's movement but still hold some of the detail accuracy in the subject. The passing bus, farther from the camera than the woman and traveling much faster, becomes a streak of metallic color. The colors are recorded in pastel tones, since speed of movement adds the effect of more white light to the shot.

Because the camera was panning with a 300mm lens and a shutter speed of ¼ second, the peak action of this bullfighter in Madrid was recorded as a slow blur. Waiting for peak action to cross the film plane will add to a color effect of movement. Here the cool, open shade and slow shutter speed provided the blended pastel shades.

second would reciprocate a 35mm lens.

When considering image movement, remember that the amount of subject movement on the film plane increases in direct proportion to the focal length of the lens. The longer the lens being used, the higher the shutter speed needed to stop motion. For example, an airplane in the distance, viewed through a normal lens, appears to be moving slowly; if viewed through a telephoto lens (and magnified), it will seem to move more rapidly and require a faster shutter speed to stop the motion. Additionally, the higher the shutter speed, the larger the aperture and the shallower the depth of field. The direction of motion affects the selection of the shutter speed; higher speeds are required when the action is more at right angles to the camera, but when the subject is moving directly toward the camera, slower shutter speeds will still freeze the action.

The choreography of the action can be best recorded across the film plane, since the slow shutter speeds convey the grace of movement of a particular subject. This type of exposure is best made

by following the subject constantly in the viewfinder and exposing and refocusing at each critical step. Since telephoto lenses flatten subjects, using wide-open apertures for less depth of field will add to the flexibility needed to use slow shutter speeds for motion effects. The longer exposures required give greater latitude in isolating the subject by blurs and out-of-focus backgrounds.

Whether or not you are using telephoto lenses, you can always stop motion. Slower shutter speeds are required to stop action that is taking place at a greater distance from the camera, since the smaller image is less apparent on the film. An image that is crossing the plane of focus on an 18mm lens, for instance, is easier to "stop" at 1/60 second than the same subject, larger in size, seen with a telephoto lens. If you want the ultimate in frozen action, use the highest shutter speed the lighting conditions will allow.

Capturing peak of action. With a rapidly moving subject (for example, a gymnast), it is often better to prefocus on where you know the peak of action will

These two seascapes in Puerto Rico are examples of predetermined stop-action photography, each using the same 24mm lens and exposure, but at different shutter speeds. The frozen peak of action in the top photo was recorded at 1/500 second; the waves-in-motion version was recorded at 1/30 second. Clearly, observation of a scene and its characteristics will help determine what type of time vision to use.

In this stop-action photograph of the Kentucky Derby you see a classic example of action moving directly toward the camera; the flying dirt clods and halted hooves of the horses add to the impression of speed. The shutter speed was 1/1000 second at f/8, with a 400mm lens, Ektachrome 400, and a motor drive set at three frames per second.

occur and wait for the subject to enter the frame. You may miss some other shots in the meantime, but you will have a good chance of getting an important shot of an exciting moment.

Autowinders and motor drives. For capturing fast action and getting sequence shots, an autowinder or motor drive is invaluable. Autowinders usually fire one shot (sometimes two) each time the shutter is released, and then automatically and rapidly advance the film. Small and light, autowinders are a built-in feature of some cameras. Motor drives are heavier and bulkier, but can operate at variable speeds, from single frames up to five or six or even more frames per second. Using a motor drive calls for some practice, however.

Many motor drives come with a built-in hand grip on the right side to help you support the extra weight with the right hand, leaving the left free for fast focusing. This can make using the camera in the vertical format a little awkward. Experiment until you find a comfortable way to hold the camera.

The rapid speed of the motor drive means that the mirror of an SLR camera is mostly in the up position as you fire off a burst of shots. In effect, then, you are shooting blind during the sequence. Focus carefully first, and keep the sequences short: remember that a motor drive set at four frames per second will burn up a 36-exposure roll of film in just nine seconds.

Be sure the shutter speed of the camera is compatible with the motor drive speed, since if the shutter is too slow, you'll end up with blank frames. Follow the manufacturer's instructions.

Exposure with motor drives involves trading off some factors. The slower the shutter speed is, the fewer the frames per second you will get. It's generally best to decide how fast you want to advance the film and then adjust the aperture for the correct exposure. If you use an automatic camera, it will select the aperture and change it if the exposure conditions change while you are shooting the sequence. If your camera is not automatic, you have less flexibility and will have to decide on an aperture and shutter speed combination before you start shooting. In that case, look for visual action that will take place under even exposure conditions.

Sequence shots can convey a very vivid sense of motion. When shooting a sequence, try to position yourself at 90 degrees to the subject, so that all its motion occurs in a plane parallel to the camera. If you are shooting a gymnast on a balance beam, for example, you should position yourself to be parallel to the beam. It is almost impossible to refocus while firing off a sequence; anticipate the action and prefocus.

4
Lenses

THE ANALOGY COMMONLY MADE BETWEEN the human eye and the camera lens is at the same time informative and misleading. Both are image-forming mechanisms employing similar optical principles — the eye receives image-forming light through the cornea and the pupil, the tiny muscles of the iris expand or contract to control the brightness of the light, and finally the image is projected upside-down and reversed from left to right on the light-sensitive retina. In a camera, image-forming light passes through the optical elements of the lens, an adjustable diaphragm controls the brightness of the light, and the image is projected on the light-sensitive film. Both your eye and the camera lens can be focused, although the camera lens focuses by moving backward and forward whereas the eye focuses by changing shape.

Here the similarities end, however, and as you work with your camera you will begin to find that it is the differences between the eye and the camera that are the most important. The first and perhaps most important difference is that the camera is a passive mechanism that equally records everything that is in front of the lens. Human vision, however, is an active process. The eye focuses selectively, concentrating on what is important in the scene and ignoring what is not. For the photographer this means that the camera will sometimes record too much—not only what is important (that is, the parts of the subject

selectively seen by the eye) but also what is unimportant as well (details or subject elements screened out by the brain). To avoid this in your pictures use selective focus, depth of field, and the camera angle and position to eliminate or subdue unwanted elements in the scene and concentrate interest on your main subject. Always make it a practice to look at the complete viewfinder frame to eliminate elements and simplify your image.

Another important difference between seeing and taking photographs is the comparative sensitivities of the retina and of photographic film. The retina is the light-sensitive layer of cells at the back of the eye; it is where visual images are formed. It can distinguish subtle differences through a very wide range of light levels in the same scene, from near darkness to blazing sunlight. Film is far less sensitive and can cover a much narrower range of light, depending on the type of film used. This means that although the eye can detect tiny differences in a scene that is very bright, very dark, or has areas of both, the film cannot. As a result, film will exaggerate lighting contrast in a scene, and this becomes more noticeable as the contrast increases. Looking outside from a dark room into bright daylight, for example, you will be able to see detail in the darker areas of the room as well as the brighter areas outside. The film, however, can usually only record detail in one of the two areas. You will lose detail

in the other; how much depends on which part of the scene was the basis for the exposure. (Hints for getting the correct exposure are found throughout this book, particularly in Chapters 3 and 6.)

There is a further complication with color film. Depending on its source, light varies in color—tungsten light, for example, is yellowish compared to daylight. Our eyes adjust to changes in the color of the ambient light so that, for example, this page looks white in any light source. The response of color film, however, is balanced for a particular color temperature. Under light of another color temperature (daylight-balanced film under tungsten lights, for example), the film will register the "wrong" colors. (For more information on color temperature and film, see Chapter 3.)

An extremely important difference between the human eye and a photographic lens is focal length. The human eye can see only in its limited focal length, and cannot (generally) focus on and determine recognizable shapes at very close or very far distances. The eye, for example, cannot focus clearly unless it is at least six inches or so from the subject and cannot watch a plane fly into the distance without it getting smaller and then disappearing from view. Photographic lenses, however, have variable focusing ranges for viewing from life-sized down to microscopic levels with the appropriate attachments. With the right telephoto lens, then, you could follow a plane much farther and retain detail that the naked eye couldn't see. Telescopic lenses can bring the photographer's eye to the very reaches of visibility: the Space Shuttle launches and re-entries have provided millions of people with views of the ship from 25 miles away, making it appear as natural to our eyes as if it were only a plane in the sky overhead. The extremes of photographic optics have vastly expanded the limits of the human eye.

"Normal" or standard focal-length lenses range from 40mm to 60mm in the 35mm format. They cover an area of 46 to 52 degrees, depending on the focal length. This is close to the angle of coverage of the human eye. The longer the focal length is, the narrower the angle of coverage is. (In 2¼-inch × 2¼-inch square format, the image area is approximately two-and-one-half times larger; the 80mm to 100mm lenses provide normal angles of coverage.)

The lens, and each design and focal length varies, is the most individual of all the working parts of the camera system. Each lens is distinct in its function, angle of coverage, and optical formula. Every time you change a lens, you are changing the visual personality of your image. With experience you will know what a scene would look like if shot with a wide-angle or telephoto, what elements of the scene would be included or excluded from the field of view, and what the range of focus or zone of sharpness would be. Practice teaches you to extrapolate from the natural 46-degree angle of view of the naked eye and predict how the picture will look.

FOCAL LENGTH

Focal length is the distance between the front element of a lens and the film plane when the lens is focused at infinity. Light rays traveling from infinity enter the lens, run parallel along the optical axis of the lens, and are made to converge at a predetermined focal point by the series of glass elements within the lens. At the focal point, each ray of light registers as a tiny point on the film plane. The convex surface of the lens bends the light as it passes through, causing it to form a cone inside the lens. If the tip of the cone hits the film plane precisely, you will get a well-defined, sharply focused image. If the film plane intersects the cone of light ahead of or behind this point of sharpest focus, the

Although an 18mm wide-angle lens was used for this shot of an aviary in Curaçao, the parallel lines remain straight and linear perspective is strongly apparent, because the lines were centered in the frame. The shadow of the bird, near the edge of the frame in the lower left-hand corner, shows some distortion.

The pronounced curvature of field of a 15mm very wide-angle lens becomes even more apparent when working close in, as in this shot of a parrot in Florida. Focus is about five inches from the bird, and the lens is tipped upward to make the horizontal and vertical lines bow out in the background.

light beams are recorded as tiny blurred disks instead of sharp points. The indistinct disks, known appropriately as the circle of confusion, are smallest at the plane of sharpest focus and become progressively larger in front of and behind this plane. Within narrow limits, the area of unsharpness is acceptable to the eye. The extent of the acceptable sharpness zone constitutes the lens' depth of focus. Depth of focus is particularly important for close-up work. It can be increased by using smaller apertures, because the circle of confusion is made smaller by decreasing the size of the diaphragm opening (stopping down).

The focal length of a lens and the image size are directly proportional; if you approximately double the focal length of a lens, it will produce an image that is just about twice as large. For example, a 100mm lens has an angle of view of 24 degrees; a 200mm lens has an angle of view of 12 degrees. As a result, an object that fills the frame at four feet using a 100mm lens would fill the frame

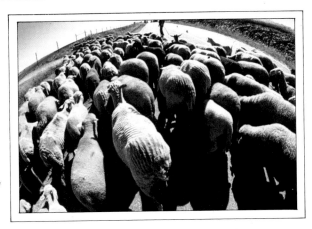

In this photograph of a Portuguese shepherd and his flock, a 16mm fish-eye lens was pointed downward from an angle above the horizon. Although all the elements converge toward the horizon as in normal perspective, the horizon itself becomes a curved bow rather than a straight line.

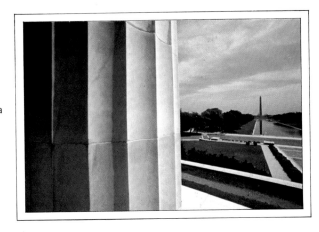

The great depth of field of a very wide-angle 15mm lens allowed both this column (only a foot from the lens) and the distant Washington Monument to be in focus. The sweeping view is held in true perspective by the level angle of the camera and lens.

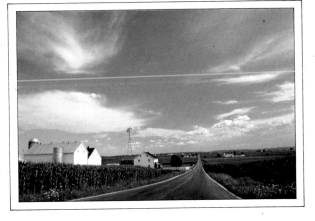

This vista of the Pennsylvania farmlands could only have been taken with a wide-angle lens, in this case a 20mm. While wide-angles outdoors give sweeping coverage, they can also make boring pictures if there is too little to fill up the space and tie the foreground to the background. In this scene, the road ties foreground to background, and the deep blue of the polarized sky is a good contrast for the white farmhouse in the middle.

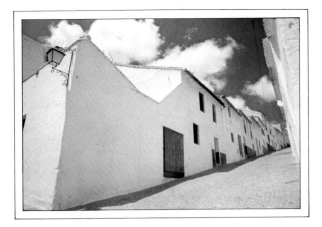

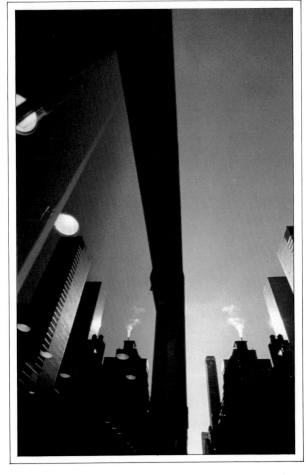

An 18mm wide-angle lens was used for both of these pictures to create deliberate distortion of perspective. In the horizontal photo of an uphill street in Spain, the low angle exaggerates the upward feeling while the walls create a triangular design. The vertical shot of Madison Avenue in New York City leans the converging lines toward a central point.

at eight feet with a 200mm lens. Image size is also closely related to depth of field. As the image on the film becomes larger, depth of field decreases; conversely, as the image on the film becomes smaller, depth of field increases. Larger image sizes require a higher standard of sharpness (depth of field) because the eye is able to discern the out-of-focus images more easily. The smaller the aperture is, the narrower the shafts of light reaching the film plane and the greater the depth of field is. While a smaller lens aperture, regardless of focal length, gives greater depth of field due to a "shrinking" of the circle of confusion, this must be balanced against another factor: an overall softening of the image at very small apertures because of diffraction within the lens. Therefore, most lenses work best when the aperture is set at a little less than its widest opening, although modern lens construction has made fast lenses especially well corrected at their widest aperture. As a rule, depth of field can be increased not only by stopping down the lens, but also by increasing the lens-to-subject distance or by using a shorter focal-length lens.

If different focal lengths are used to photograph the same object from the same distance, the shortest focal-length lens will record the view on the smallest scale, but will include the greatest picture coverage area—the widest angle of view. Longer focal-length lenses will cover less of the subject—a smaller picture angle—but will record it on a larger scale. Therefore, the scale of reproduction, or reproduction ratio, is proportional to the focal length.

Depth of field and the application of its abstract qualities can be used to add atmosphere, eliminate confusion and unwanted backgrounds, isolate and draw attention to a particular subject, or show a gradual decrease in sharpness over a wide field, as, for instance, in a picket fence that appears sharp on the first several spokes but decreasingly loses focus as it recedes into the background. This is the zone of focus in a photograph: just how much is to be included in the frame in detail and focus and over how much of a field of view. Learning to understand and use focal length and depth of field is paramount for better photography.

WIDE-ANGLE LENSES

The wide-angle lens is the photographer's tool to expand space and distance, and to experiment with dimensions and perspectives. Wide-angle lenses offer the photographer a wide angle of view and great depth of field, but the same lens construction that gives this flexibility also leads to a certain amount of distortion. With understanding and practice, however, distortion can be reduced or eliminated and the wide-angle can be used to create new vantage points and exciting effects. Wide-angles are particularly useful for photographing sweeping vistas, for accenting vertical perspectives, and for shooting in limited spaces.

The primary problem with wide-angle lenses, however, is distortion of perspective. Rather than the rectilinear perspective given by other lenses, the sharply curved front element of wide-angle lenses can create a curving effect that makes straight lines seem to converge and flat planes seem to bulge. This effect will be exaggerated if the camera is tilted; if it is held level, the effect is minimized. An additional problem encountered with the wide-angle, also a result of lens construction, is light fall-off toward the edge of the picture. Although most modern wide-angles are corrected to compensate for this, vignetting may still occur, especially if the lens is used with a lens shade.

The term wide-angle generally refers to lenses with a focal length of between 15mm and 35mm. The shorter the focal length is, the wider the angle of coverage, the greater the depth of field, and

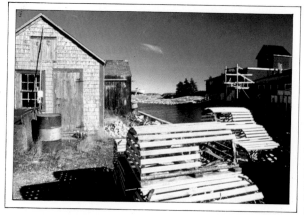

Because of the way that they "see" space, wide-angle lenses are useful for opening up cramped areas. In this picture taken in a small fishing village in Nova Scotia, a 24mm lens was used to push back the scene and separate its elements. The camera was held level and the angle was somewhat low to avoid noticeable distortion of false perspective.

also the greater the distortion are.

Fish-eye lenses. Strictly speaking, a true fish-eye lens has a 360-degree, or completely circular, angle of coverage. Lenses of this sort are used chiefly for scientific purposes. The creative photographer usually uses a fish-eye lens with a focal length of anywhere from 6mm to 16mm, giving an angle of coverage from 220 to 137 degrees. Some fish-eyes give a circular, vignetted image on the frame; others allow a full-frame image characterized by a great deal of barrel distortion. Fish-eye lenses are quite slow; most have a maximum aperture of only $f/3.5$ or $f/5.6$. Used sparingly, the fish-eye effect is a powerful one, but choose a subject that will not be overwhelmed by the lens.

Very wide-angle lenses. The group of lenses with focal length ranging from 15mm to 20mm are known as very wide-angle lenses. A 15mm lens has an angle of coverage of 100 degrees, an 18mm lens covers 90 degrees, and a 20mm covers 84 degrees. Although these lenses are corrected to reduce distortion, the problem is still very real at these focal lengths.

Medium wide-angle lenses. The medium wide-angles, such as the 24mm, 28mm, and 35mm lenses, are the focal lengths most popular for photographing vistas. They are useful for delicate but subtle elongation of perspective, and extremely

Because this photo of sunset on the Gulf of Mexico was taken with a 15mm very wide-angle lens, the waves and clouds converge in a sweeping arc toward the horizon, and the sun appears only as a glowing dot. With the camera held about two feet above the water to ensure an even horizon line, the same scene shot with a long-focus lens would have made the sun into a huge yellow disk.

Even with the wide angle of vision and great depth of field of a 35mm lens, selective focus is still possible and effective. Here the lens was used at its widest aperture and the focus was straight ahead. The large opening combined with the closeness of the subject produces a three-dimensional feeling of the hand reaching out.

helpful when working in a confined area. Because a moderate wide-angle has a greater depth of field and angle of coverage than a normal lens, it gives a cramped area a feeling of depth and spaciousness without serious distortions.

Photographers are often admonished not to use a wide-angle for pictures of people, particularly portraits. A close-up of a face using a wide-angle lens will indeed provide a distorted, unflattering portrait, an effect that is rarely desirable. With care, however, a wide-angle lens can also be used to enhance pictures of people. By taking advantage of the greater depth of field and angle of coverage of the wide-angle, a photographer

is able to get both the face of the subject and the background in focus and to show the person in his environment. If a medium-format wide-angle is used on a camera held level and the subject is centered in the frame, distortion will be minimal.

MEDIUM TELEPHOTO LENSES

For pleasing, frame-filling portraits, for isolating details, for magnifying the image, and for compressing the elements of a landscape, the ideal lens is a medium telephoto. Ranging in focal length from 85mm to 135mm, medium telephoto lenses are lightweight, easy to focus, and fast, though not as fast as

A 28mm wide-angle lens with a 74-degree angle of view opens up this narrow street, alive with color, in Mexico. The wide-angle made possible a compositional play of colors and shapes that the off-center mother and children (and their shadows) make more interesting as a design.

A 50mm *f*/1.4 lens photographed the golden interior of this French cathedral, providing that extra speed of a fast lens needed to get the picture—the meter reading was 1/30 second at *f*/1.4.

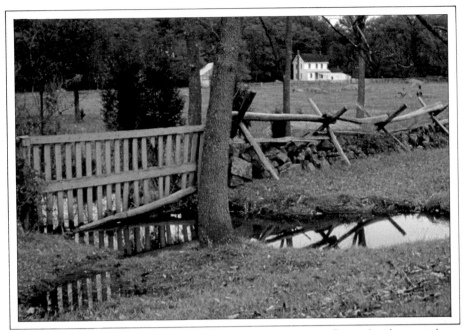

The small cottage and fence on a rustic fall day in Gettysburg, Pennsylvania was taken with a standard 50mm lens. The focus is on the center of the photograph, and the angle of view and perspective are similar to what the naked eye would see; the feeling of depth is shared equally by the foreground and background.

Even with a normal lens, the limits of human vision can be extended. The naked eye could never have taken in all the detail of this lagoon in Puerto Rico at once. But in this photograph taken with a normal lens at f/16, the waves in the background and branches in the foreground are all in focus at the same time.

The light was low and the flamenco dancer was in constant motion in this small club in Spain. A 35mm lens, a shutter speed of 1/30 second, and Ektachrome 400 captured the action and preserved the ambience of the evening. The dancer's face is sharp, while the blurred hands convey a sense of motion.

most normal lenses. The angle of view is considerably narrower; an 85mm lens has an angle of view of 28 degrees, a 90mm covers 27 degrees, and a 105mm covers 23 degrees. A 135mm telephoto has a narrower angle of view, covering only 18 degrees. Depth of field gets shallower as the lens gets longer.

Camera shake is more likely and noticeable when using a telephoto lens. Use the fastest shutter speed possible under the circumstances, and support the camera firmly. A good rule of thumb is to make a fraction of the focal length and use that as the slowest shutter speed. For example, with a 135mm lens, a fraction would be 1/135. Use the closest shutter speed, in this case 1/125 second.

For portrait work, the medium telephoto allows the photographer to fill the frame with the subject from a distance of about four or five feet. For candid photography, it is useful for picking out

Image size is drastically affected by the focal length of the lens. In this picture, taken in Holland with a 21mm lens, the short focal length makes the horses into tiny figures set against a sweeping horizon line and massive backdrop of storm clouds.

a face in the crowd and isolating it, by using the narrow angle of view. The same technique can be used for other subjects as well, such as architectural details, and for avoiding extraneous details on either side of the picture. Unwanted detail in the foreground or background can be eliminated by using the shallow depth of field to turn the detail into indistinguishable blur.

Telephoto lenses compress the perspective of a scene, making the distance between objects in the foreground and background seem less than it really is. This compacting effect is often used to advantage in photographing landscapes as a way to tie the foreground and background together into a unified whole. It is also an effective way to photograph sunrises and sunsets, making the sun into a large, glowing disk.

A good photographer will always try to get as close as possible to the subject.

When this is impossible, a medium telephoto is often the solution. The magnification provided will fill the frame from a distance without distortion.

LONG TELEPHOTO LENSES

The next step beyond medium telephotos is the group of long telephoto lenses, including lenses with focal lengths of 180mm, 200mm, 250mm, 300mm, 400mm, and longer. Although some telephoto lenses have focal lengths as long as 1,000mm or more, their uses are highly specialized. For all practical purposes, the longest lens any photographer is ever likely to need is 600mm.

All the factors to be considered when using a medium telephoto lens apply to long telephotos as well, but more so. Long telephotos are heavier, slower, and have narrower angles of view and less depth of field. Relative motion appears greater with long lenses, requiring faster

An 85mm telephoto was used at f/5.6 to separate the main subject, a stone head of the pharoah Ramses, from the secondary subject, the man who is its guardian. This shot was taken in Memphis, Egypt.

A 105mm lens at a medium aperture gave three-dimensional depth to this photograph of Royal Marine Cadets in England. The focus was on the cadet officer in front; the cadets behind him recede into space and gradually become out of focus. This is an excellent example of using depth of field to advantage.

The 105mm medium telephoto is ideal for portraits, as the pleasing facial proportions of this Scotsman show. The subject-to-camera working distance is comfortable for both photographer and subject, and it is easy to isolate the face by using the lens's widest aperture.

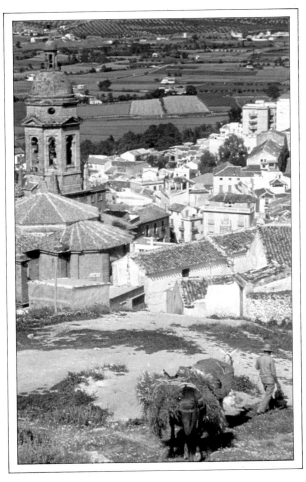

This picture, taken in a small Spanish town, has the appearance of normal vision even though it was taken with a medium telephoto. An 85mm lens gave the impression of continuous depth of field over the long vertical vista.

shutter speeds to capture motion; at the same time, many long lenses have maximum apertures of only $f/3.2$, $f/4.5$, or even $f/5.6$. Unless you have a very steady hand or something solid to brace the camera on, a strong tripod is essential.

Some additional problems develop when using long telephotos. Atmospheric haze, thermal disturbances, and bluish ultraviolet casts are more evident in pictures taken with long lenses. The bluish cast can be reduced with a skylight filter or polarizing screen. About the only way to reduce haze or heat waves is to take the picture at a different time of day or on a different day altogether. Chromatic

aberration is also a problem with long lenses, although recent technology has sharply reduced this in newer lenses.

Mirror lenses. As the name suggests, mirror, or catadioptric, lenses use internal mirrors to compress a long focal length into a compact area by bending the light back and forth within the lens. For example, in a 600mm mirror lens, the light, rather than traveling the length of a 600mm-long tube, is instead folded within the lens by mirrors for the equivalent distance.

Clearly, the chief advantage of a mirror lens is its compact, light, easy-to-hold form. For this reason, mirror lenses are

A 200mm telephoto lens with Ektachrome 400 got this head-on portrait of a tiger in the Bronx Zoo in New York City. The narrow angle of view permitted filling the frame with the tiger's face and eliminating most of his cage.

For isolating a subject from a disturbing or confusing background, a telephoto lens is ideal. This matador in Madrid was captured by a 300mm lens on a tripod.

This head-on view of tree and field on a bright afternoon became a two-dimensional tapestry by using a 300mm telephoto at a shutter speed of 1/500 second.

The stacking effect of a 400mm telephoto lens can be seen in this picture of a quiet Portuguese mountain town. The houses appear compressed together with no space between them; all seem to be about the same size.

frequently used for sports and wildlife photography. Another advantage is that the combination of mirrors and fewer lens elements reduces chromatic aberration significantly. But at the same time there are also a lot of disadvantages to using mirror lenses. They have fixed, small apertures (usually $f/8$ or $f/11$), so exposure must be controlled through the shutter speed or by using neutral density filters placed between the lens and the camera body. In addition, they have very narrow angles of view, very shallow depth of field, and cannot focus closely.

A characteristic problem with mirror lenses is out-of-focus doughnut-shaped rings in the background of the picture. With regular telephotos, out-of-focus highlights are rendered as blurs. But because a mirror lens has no diaphragm, and because its aperture is doughnut-shaped, the blurs become little rings. If the background is neutral, say leaves or water, this makes little difference. However, if people are in the background, they may seem to have holes in them — an effect obviously to be avoided.

ZOOM LENSES

In recent years, the improved optical quality of zoom lenses has made them increasingly useful and popular. The continuously variable focal length of zoom lenses makes them indispensable for any situation where access to the subject is difficult or where the subject moves quickly. In sports or wildlife photography, for example, the action is often too fast for you to continually change lenses. With a zoom, you can capture the action and fill the frame, using just one lens and without changing position.

Zoom lenses are available in many different ranges. The most popular are 35–70mm, 80–200mm, and 100–300mm. Early zooms were justly criticized for problems of excess weight, poor image quality, and lens flare, but these have been virtually eliminated by modern

In this scene of the Italian countryside on
a hazy summer afternoon, the compression
effect of a 500mm mirror lens is quite
acceptable to the eye, because the images
are separated by a distance that seems
in proportion and natural.

The versatility of zoom lenses is demonstrated by these two photographs of the same sunset on a California beach. In the vertical shot, the 80–200 zoom was set at 200mm, making the sun into a large disk, giving a stacked look to the waves, and requiring selective focus on the two seagulls. In the 80mm horizontal version, the scene is changed considerably: the depth of field is greater, the sun is smaller, and more of the ocean can be seen. The same aperture, f/8, was used for both shots.

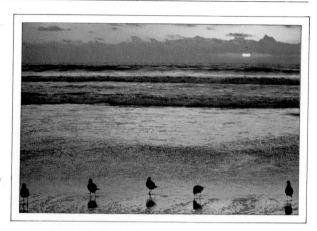

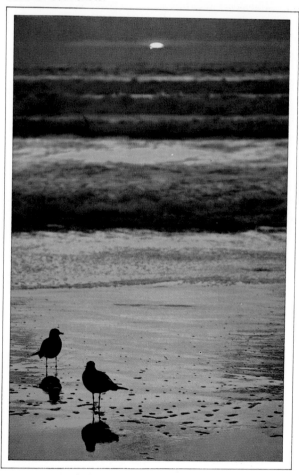

A 55mm macro lens was used to take a hand-held close-up shot of a market in Morocco from only a foot away with sharp resolution and no distortion. This picture was shot on Ektachrome 64 pushed to ASA 250 for extra speed and grain.

optics. Zooms remain somewhat bulkier than fixed focal-length lenses, but this is a trade-off against the weight of carrying different lenses. They are also somewhat slower and focus somewhat less closely, but again, convenience must be weighed against the drawbacks.

An interesting special effect can be created by zooming the lens during a long exposure. The zoom-blur effect can give an illusion of motion and create beautiful abstract patterns on the film.

SPECIAL-PURPOSE OPTICS

Perspective control lenses. When tall, vertical subjects, such as trees or buildings, are photographed from close up, they often seem to tilt back or converge in the picture. This happens because the photographer must tilt the camera to get the entire subject into the frame; tilting the camera means that the film plane is no longer parallel to the subject plane, and the result is tilted or converging vertical lines. By using a perspective-control (PC) lens, however, this problem can be avoided. The front element of a PC lens can be moved up and down to remain parallel to the subject plane, while the film plane remains in position. This gives an accurate rendition of the subject's perspective. Most PC lenses have a focal length of 35mm; the amount of tilt is generally around 10 degrees.

Macro lenses. Most camera lenses are designed to perform best at their normal focusing ranges, anywhere between about three feet and infinity. Macro lenses, available in focal lengths of 55mm, 60mm, and 105mm, are designed to be at their best when focused closely for reproduction ratios of 1:1 (life-sized) or even 1:2. For greater depth of field in close-up work, most macros can stop down as small as $f/32$. The maximum aperture is rarely larger than $f/2.8$.

An often overlooked aspect of a macro lens is its potential as an all-purpose lens. A 60mm macro lens has an angle of view of 39 degrees, just slightly narrower than that of a 55mm normal lens. Although it is slower than most 55mm lenses, the maximum aperture of $f/2.8$ is wide enough for most photography. In addition, it is equally sharp at all distances and sharper at close distances.

5
Filters

Two types of filters are most associated with color film: light-balancing filters and color-correction filters. Light-balancing filters modify a given type of incident light into the type of light for which the color film is balanced. Amber filters such as 85B have a warming effect on the light; when used with tungsten-balanced film (3,200°K), they create an acceptable substitute for daylight film. Conversely, deep-blue filters such as the 80A can be used with the cooler tones of tungsten-balanced film to create a fair substitute for daylight. The density of the filter, or the filter factor, must be considered in your exposure. From one to two stops in exposure may be lost, but if you need the filter for the shot to happen at all you can make appropriate compensations. Naturally, when you are using a through-the-lens meter, the light will pass through the filter before reaching the meter, and compensation will be automatic. Since light-balancing filters are deep blue and dark amber, you will see those colors when taking the picture. The developed film, however, will show a correctly balanced color photograph.

On overcast days there is an overabundance of bluish ultraviolet light in the atmosphere, which will affect the color rendition and create a colder impression on the film than was actually experienced. To compensate for this shift to the blues, skylight filters or light amber filters (the 81 and 85 series) can be used to add a warmer, more natural look to the photograph.

These filters can also be used to modify the blues of open shade into a more acceptable appearance on the transparency film. Since the skylight filter cuts the haze that is prevalent in the atmosphere, it can be used with telephotos for any type of distance shot to cut down the haze that is amplified by the telephoto. The light- and medium-amber filters can be used to warm up any scene you feel needs the alteration. An increase of one-half to one f-stop will enhance the filter's effect; an overexposure will lighten the color cast. An ultraviolet (UV) haze filter will work much as a skylight filter does, eliminating haze without any visible alteration to the color. Unlike the skylight filter, there is no slight warming tone to the ultraviolet filter. Skylight and UV filters require no compensation in exposure. These filters should be used when you are working outdoors in any type of hostile environment: drizzles, beaches, snow, or city streets and open areas where particles of water or grit can reach the lens and harm it. Because filters are usually glass, it is always wise to use a lens shade when working with them; this prevents any glare or reflections from cutting down the filter's effect or unduly influencing the exposure.

Color-correction filters are made specifically to give you additional control over the color atmosphere of the scene and are used to correct color shifts caused by artificial lights (for example, fluorescent, mercury vapor, or sodium

vapor lamps), color casts, and reciprocity failure. They are designated by the letters CC, a number indicating strength (05, 10, 20, 30, 40, and 50), and the color (red, blue, green, cyan, yellow, and magenta). Thus, the lightest red color-correction filter would be indicated by CC05R; the darkest, by CC50R.

It is difficult to be precise when correcting the color balance of lights, particularly fluorescents. Try holding the color-correction filter to your eye to estimate its effect; even then, try several exposures using filters of different strengths. In general, fluorescent lights give a greenish cast, but you can correct for this by filtering daylight film with green's complementary color, magenta. The more severe the color cast, the darker the filter you should use. A red filter will correct the bluish cast of mercury vapor lights, while a blue filter will correct the yellow color of sodium vapor lights.

Color casts with natural light usually happen when the light passes through a

A light amber filter was used with a 200mm lens to photograph this unique barn in Quebec. On a rainy day such as this, the filter did more than restore some of the original color to the scene; it added a more pronounced but not unnatural warmth to a picture that would have been recorded by the film in monotones of bluish-gray. The red door, for example, would have lost its impact to the overall haze. A skylight filter would have had less of a warming effect.

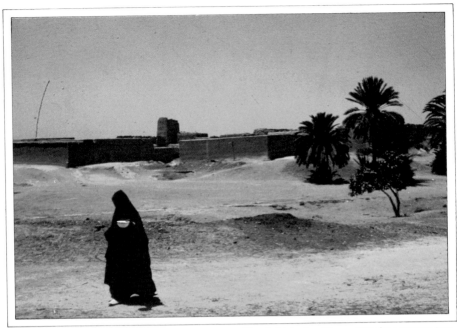

The light in the Moroccan desert was too bright to shoot without a neutral density filter. A 105mm lens, Ektachrome, and a neutral density filter with a filter factor of four reduced the amount of light by two stops without changing the colors.

colored, translucent surface. A good example of this is the greenish tinge seen on the face of someone standing beneath a leafy tree on a bright day. Though color casts sometimes add a pleasing effect to the scene, they should be avoided when photographing faces. Use a filter of a color complementary to the color cast to reduce or eliminate it.

On the cool end of the color-correction filter scale, blue filters will remove the excess reds and oranges that appear in sunsets and early-light photography, neutralizing the colors and converting the light's color balance to a more acceptable rendition of the original scene. In some cases, you may want the film to overreact to the excess red in the atmosphere in order to create an extremely "hot" exposure; in other cases, you may want a more balanced color range in the photograph if you think certain colors should be prominent and accurate in the main subject or if skin tones are an important part of the shot. Medium-blue filters add pseudo-moonlight effects when

A Moroccan farmer standing in his cornfield in the intense side light of late afternoon was further enhanced by using a light-red color-correction filter to emphasize the rich golden light, rather than correcting the balance with a light-blue cooling filter. A 200mm lens used with Ektachrome 64 pushed to ASA 250 increased the graininess of the film as well as the depth of field of the telephoto.

shot with daylight film and underexposed several stops. This technique works well with seascapes, specular highlights on water, and in snowscapes.

During long exposures, reciprocity failure can cause color shifts, which can be corrected by additional exposure or color-correction filters, or both. For more information, see Chapter 3 and the manufacturer's instructions for the film you are using.

NEUTRAL DENSITY FILTERS

In areas of extreme brightness, such as snow scenes, beaches, and deserts, the light levels may be too high for accurate control of exposure; neutral density filters can be employed to cut down the overall amount of light reaching the film, thus giving you further control over the aperture and shutter speeds. These filters can effectively reduce the overall image brightness of a scene without causing a color shift in the film, since they have no visible effect on the light that passes through them. Plain gray and available in densities that range from one through several stops, these filters can be used in conjunction with other color filters to reduce the exposure time without interfering with the color characteristics of the other filter. When you are using more than one filter, try to shoot at less than the widest aperture of the lens; stopping the lens down two or three stops will make working with stacked filters on medium and long telephotos possible without too much visible interference. Stacking filters is not an advisable technique to use with wide-angle lenses since vignetting will result in image cut-off.

POLARIZING SCREENS

A polarizing screen is a great asset to the color photographer. This unique device (it's really not a filter at all) allows light vibrating in only one plane to pass through the lens. It eliminates reflections

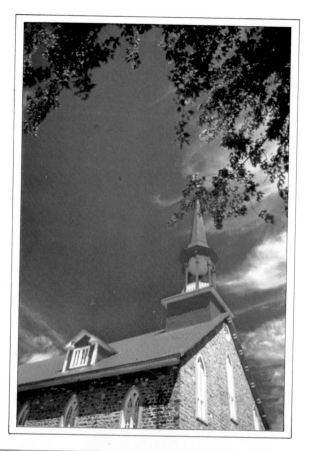

Both of these photographs were taken with wide-angle lenses and polarizing screens. They represent the maximum amount of sky-blue color saturation that could be seen in the viewfinder when the polarizer transformed the colors into a darker hue. The church was shot with a 24mm lens; the glare off the roof was eliminated by the screen. The leaves of the tree retained their chromatic color values: they're not too dark, and they're still green. The plane was photographed with a 200mm lens and polarizer, again rotated for the maximum result. In this case, the metallic surface was painted, so the filter removed only the reflections and glare of the sky from the scene.

from bright nonmetallic surfaces, controls the brightness of the sky, and increases overall color saturation. When working at right angles to the sun, the polarizing screen can be rotated to darken a blue sky to the deepest possible hue. With rich, saturated blue skies, the white clouds seem to pop out and the contrast range of the color is at its most extreme. The polarizing screen will only darken a blue sky when the sky has some blue in it already, though; it cannot alter the color of a gray sky on an overcast day. Maximum results are obtained in side light and over-the-shoulder front light. Another distinctive feature of the polarizer is its ability to remove surface reflections from water and glass and to reduce reflected glare from foliage, sand, and the like.

An increase in contrast is inherent with polarizing screens; the amount of contrast is regulated by the rotation of the screen. After viewing the desired effect, you can take the most accurate light reading with a through-the-lens meter

The colors of the flowers and the coats of the two women were further enhanced by a polarizing screen, which removed the unwanted reflection of the blue sky and saturated the colors to their deepest hue. Complementing the colors were the textures and shadows of the composition. The scene was shot in London using a 24mm lens and polarizing screen.

These trees were shot on an overcast but bright day. When the sun started breaking through the clouds, the red filter produced a red-yellow vividness in the overall color atmosphere of the photograph. The shot is one stop overexposed to compensate for the filter. Setting suns and underexposures (two or three stops) can produce sun disks that seem to glow with color. This was taken with a 28mm lens and Ektachrome 64.

Orange or deep-yellow filters can also be used to highlight and enhance sunsets, sun disks, and skies. A 400mm lens with an orange filter captured these birds sitting on a buoy in the Gulf of Mexico. The disk is white rather than orange because the medium-orange filter is not too deep in color density and the sun was at its brightest peak. The exposure reading was taken off the sky where the sun was not a factor.

The stone bridge in Antietam, Maryland on a hot summer afternoon, seen across the softly shaded green riverbank, gives this shot an air of rustic tranquility. The white light from the slight overexposure has, in conjunction with a diffusing filter, washed the color out slightly to alter the atmosphere; recorded by a 35mm lens with Kodachrome 25.

measuring the now-polarized light. Since the polarizer cuts down on light, a loss of at least two full f-stops can be expected. Examples of polarizing screens and their uses appear in photographs throughout this book, since in the field they are indispensable when confronting the dynamic world of nature, color, and light.

BLACK-AND-WHITE FILTERS WITH COLOR FILM

Filters that were designed exclusively for black-and-white use with panchromatic films can also be used with color film for special effects. A deep red filter, for example, can be used to shoot sunsets and bright cloudy patches to produce "hot" color. Green filters can be used to add color intensity to grass and leaves when the sky will not be in the picture (a green filter will make the sky appear an odd green color). Light yellow filters can be used to lighten the greens in general landscapes with large amounts of trees and foliage. It is important to keep in mind that while these filters are great

A gray day on the Thames in London made these boats seem like a good subject, but the color atmosphere was drab and gloomy. Two split filters, a 30 percent red for the sky, and a 30 percent blue for the water, blended the colors into another dimension, one that has a color, depth, and a look of animated brightness. The slight diffusion effect was created by stacking the two filters together. The widest aperture of a 35mm lens was used with Ektachrome 400.

The moors of the Lake District in England were the setting for this early autumn landscape, photographed in a gray drizzle on Ektachrome 400 with a 50mm lens. A split filter was used to add a 20 percent red tint to the sky. The low-hanging clouds were intensified by the red tint and created a feeling of closeness and humidity. The warm tones of the sky reflect in the natural and accurately portrayed grass.

The contrasting colors and chromatic brightness make a lunarlike landscape out of the dry plains of Estremadura, in Spain. A bright purple filter with a polarizing screen saturated the color contrasts of the scene and created color in disarray. Compared to "normal" color, the shadows have tint, the rocks vibrate, and the distant plateau is dark in color value instead of having the hazy light of distance.

aids in adding graphic impact or color subtleties to a particular film or scene, they are not the end-all solution to the various photographic experiences that await the alert photographer. The filters are, however, responsive tools in the right situation at the right time.

SPECIAL-EFFECTS FILTERS

Diffusion filters, halo filters, soft-focus devices, and the like all fit into the category of special-effects filters. They are visual aids that make variations on photographic themes possible. Diffusion and soft-focus both work on the same principle: the scattering of light as it is reflected from colored objects. These filters soften parts of the scene, with

The ominous dark clouds that hang over the church steeple in this fiery sunset in Spain have been dramatized by underexposure with a red vibrachrome filter. The clouds are in actuality the branches of a tree, thrown out of focus by the wide-open aperture of a 200mm lens, which also distorted the depth dimensions by its compression effect.

greater effects of diffusion and halo diffraction taking place in the brighter areas or by the light source itself. Good subjects include specular highlights in water, sunlight back lighting hair, and window light. Extremes in halo effects can occur when shooting directly into a partially obstructed sun (behind trees, through leaves, from behind structures, and so on). Diffusion filters are good for portraits in bad lighting conditions as well as for portraits under strong back-lighting conditions, where diffraction effects and glare can add interest to the picture. Maximum results can be best achieved in scenes of unusual brightness or high contrast, although good results can be gained from any scene with one strong or directional light. This type of manipulation of a scene calls for a solid exposure upon which to base the strength of the picture. The standard principles of light readings are used to make the best of the color exposure. Moderating the exposure to enhance or to lighten the effects of any

filter is important, and the particular problem areas of light in the scene should be viewed and metered through the lens while the filter is on.

An interesting type of filter to use when dealing with "flat" light or washed-out skies is the split-color filter. Several optical manufacturers have produced filters with color gradations that cover half the lens with a particular color tint (red, yellow, blue, green, amber) that is still subtly balanced enough to work with color film in outdoor lighting conditions. The other half of the filter is clear. These filters range from a dark to a light tone and can be rotated around the lens until the desired color effect is seen. This makes it possible, for example, to place a green-tinted filter on the portion of a scene that has foliage, bringing out the greens, while including the unaltered blue sky in the photograph. With a blue filter, you can simulate a blue sky without adding any blue to the nonsky portion of the picture. These special-purpose color combinations obviously have to be practiced before a natural look can be consistently obtained, since color added to only one area of the film must look balanced and real (acceptable) in the finished transparency. Overuse or too many combinations of special-effects filters together can falsify a scene rather than help it.

CHROMATIC AND VIBRATING COLOR WITH FILTERS

The color we see in a transparency is balanced for the three primary colors. Adding filtered light that is purely chromatic in content gives startling results, since the "acceptable" spectrum has been disrupted and "false" color of a high hue value has taken its place. Because we are unfamiliar with this new spectral light, its effects assault our color senses. Color by association, our preconceived memory of perception and color proportion, no longer exists. In its place are "artificial" hues, shades, and tints of all intensities that call for the eye's attention. The goal is to disrupt the scene's natural color balance and create a new experience of psychological response. Since this is a deliberate step whose effects include concentration on the tonal color of the picture as the main concept, it is an experiment in pure impressionism.

The filter factors for various types of specialty optics are included in the manufacturer's instructions. Through-the-lens metering systems have made exposure with filters more predictable and accurate and easier to use. Still, a full understanding of the filter's exposure value and its response to a scene has to be practiced and understood for the "feel" of the filter to become spontaneous.

6
People

THE PHOTOGRAPHER IS A COMMUNICATOR: he thrives on the unexpected event, the commonplace, the unusual vision, or the starkest side of reality. In a sense, then, the ultimate goal of the photographer is to produce an original facsimile, a visual statement with impact that will bring a direct communication of the living scene to the viewer. It is here that the photographer-technician turns photographer-artist.

One of the most interesting projects to assign yourself for the study of color as an aspect of photography is to do a series of pictures dealing with people in their environment. This type of study provides guidelines for working with various color forms, angles, and exposure factors, while at the same time enabling you to make statements with people as an integral, but not the only, part of the photograph. This type of assignment can be done literally anywhere. Photographs are, after all, where you find them: streets and parks merely provide a backdrop for a visual slice of the local life. Some of the most rewarding photos are taken on small, out-of-the-way roads, where the less formal and more localized situations can be found. Here, photography becomes a walking game; any turn or street can open up a new world of experiences. Look for small, distinctive portions of walls or windows against which a person may be placed as a main subject. The window may be vacant when you first see it, but later on, if someone is there, you will be ready to shoot, since you have already figured out the angle you want and have a good idea of the potential composition and color strengths of the setting.

Normally we don't pause to look at these scenes; but if you stop a person in the right framework you may have a superior representation of his environment. A great number of so-called "grab" shots are actually done this way — by scouting out an area earlier, carefully searching for the elements that will make the greatest contribution to the picture (background), and then constructing the photograph around that base.

It's usually best to exclude a lot of detail from a picture, as it tends to make the photograph busy. Stress instead simple forms and sound composition. Once you have chosen your main subject, concentrate on what you don't need in your photograph and constantly look through the viewfinder and change your angle to construct the simplest and strongest composition. Once you have determined a basic composition, you can plan where the key character can be placed by waiting to take the photograph at the right moment.

CANDIDS

There are many varying and conflicting philosophies on the practice of photographing people. Each individual has a very distinct personality; for that matter, you have your own personality as a communicator, a translator of people and events, a messenger bringing visual

images. When you pick it up to shoot, the camera disrupts these normal channels of communications between people, and opens up an immediate and quite different set of responses between you and your subject. When your camera intervenes between the normal face-to-face confrontation, you become an intruder, a stranger with a machine, while the person you focus on becomes merely someone who does you the favor of posing or acting or just plain being—but all for the purpose of *your* photograph.

It's almost astonishing how effective a smile, a please, and a thank you can be in getting your subject to cooperate in the seemingly exploitative process of taking a picture. Never forget elementary courtesy. There are times, however, when your subject makes it clear that he doesn't want to be photographed. That is a right you must respect. To photograph unobtrusively in such situations is a challenge you can meet in several ways. One of the best is to pre-set your camera and take the shot with the camera away from your eye—while it is hanging from your neck or held at your waist, for example. It helps to be quick at setting the exposure, advancing the film, and cocking the shutter, and to have a quiet camera. Your camera can also be concealed under a coat or in a bag, if necessary. If you must use a slow shutter speed, pre-set the camera, put it on a flat surface, and look the other way as you release the shutter.

Using a long-focus lens will enable you to fill the frame from a distance and is a basic technique for candid photography. The telephoto's shallow depth of field has the double advantage of being good for isolating a subject from a distracting background and allowing you to work at a distance.

Concealed vantage points are another way to get candids, especially when you can look down on your subject from a balcony or a second-floor window, for

A slow shutter speed captured some
motion as this boy ran past. The slight
blur of his figure broke up the solid
geometry of the wall and balanced the
whites and other colors in the photograph.
The even distribution of light in this
picture is provided by open shade; an
85mm telephoto lens was used with
Kodachrome 25.

example. People look to the side and down, but rarely look up. A longish telephoto is best for this situation.

INFORMAL PORTRAITS OUTDOORS

Since the eyes have been accurately called the mirror of the soul, watching them will reveal the strongest part of your subject's visual personality. Clearly, then, it is crucial that the eyes be in focus in the picture. People have different attitudes as far as looking directly at the camera (and thus at you as photographer), or looking away from it while still posing for you. While you are shooting your subject, moving in a little bit at a time will get him to look directly into the lens. This eye contact is all important. His expression and personality take on a new identity; now he is observing you and his eyes will show it. This is the second for which the photographer waits. That first look should be captured, the rapport should be built on, and the results of being prepared for that important eye sequence will show in the final picture.

If you have a definite choice between

This street scene in Portugal is a new view of life, created by a 28mm wide-angle lens. In this "split" composition, the man knowingly posed, sitting in the direct sunlight. Although the woman on the donkey is in the darkness of the corner's shadow, the eye is led to her. She seems unaware of the photographer. The angle of the lens adds an impact to a scene.

The opposite of the preconceived picture is the "grab" shot, like this woman and child in the doorway. As I was photographing the whites and greens of the window, the shade suddenly opened, revealing the people. The even illumination of shadow detail is the result of open shade. The light exposure was a general reading of the whole frame and a 105mm lens was used at full aperture.

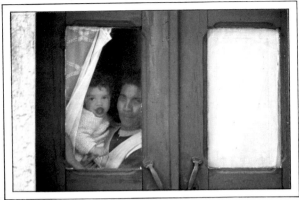

This wall, with its harmoniously colored window, shot in the last light of day on the island of Rhodes, became a more interesting photo when the mother and her children suddenly emerged. They were unaware of the camera for a second; then they saw it and started to react. A 105mm lens, Kodachrome 25, and a shutter speed of 1/60 second were used.

These two Amish boys, shot in Pennsylvania, illustrate side lighting in late afternoon. A 500mm lens brought the scene together and shortened the distance between the two boys. The meter reading was a general reading of the whole scene.

photographing in the shade or in direct, hot sunlight, by all means use the advantages of the shade. Shade reduces the sun's glare so the subject won't squint or try to avert his eyes.

Open shade, which is fairly bright and gives even, diffuse light, is the ideal lighting for informal portraits. The skin tones and colors seem more subtle and softer, and detail is clearly visible. More importantly, the subject is often more comfortable in the shade and therefore more relaxed.

If open shade isn't possible, your job becomes a little harder. Avoid harsh overhead lighting because of its sharp, dark shadows: your subject's eyes could appear as ugly black pits. Low side light, as that from a late afternoon sun, is very good for faces, since it models the details and brings out the textures. A back-lit silhouette can make a very effective portrait, but you should avoid

This workman in Portugal was shot with an 85mm lens at its widest aperture to exclude any background interference. The light was open shade with reflections from a white wall directly behind me. The added light from the wall served as a reflector does in the studio: it filled in the shadows and added saturation to the colors. The light reading was taken directly from the face; the film was Kodachrome 25.

underexposure. Enough detail must still be visible in the face to reveal something about the person.

AVAILABLE LIGHT

In the art of photographing people, you will find yourself in the position of being part performer, part guest, and part interpreter. This role playing will always be with you no matter where you find yourself, indoors or out. You must bring your eye and charm indoors with you and work in confined, poorly lit interiors if you want to find people in their most relaxed and natural state. The cafés, taverns, or homes you enter in hope of finding great subject material serve as perfect shooting locales for the more intimate types of portraiture. The local color, the strangeness of the situation, the quality and quantity of light, the dominant colors, the mixture of personalities cramped into a small working

place — all provide the challenge and joy of capturing a moment on film. Faces are different indoors because of the ambient light, its color, and the low light levels and shadows in the scene. Most indoor scenes (other than those drowned by the overbearing, flat light of fluorescents) are somewhat dramatic. They have an atmosphere already, and it is up to you to capitalize on this.

Firelight and candlelight can be lovely, soft, and flattering for portraits, but exposure can be a little tricky, as there is a tendency to overexpose. In general, the meter reading will be accurate, but try to use the fastest possible shutter speed to catch the movement of the flames.

Shooting people in poorly lit interiors presents some special problems, but there are still ways to get good shots. The important thing is to see the positive artistic possibilities of low-light situations. People as a rule are more relaxed

The photograph of the Moroccan farmer was taken from very close to the man's face, using a fast 28mm lens with Ektachrome pushed two full stops, illustrates how the predominant color of the immediate environment influences color film to respond to it alone as a main source of light. The farmer was wearing a large yellow straw hat, and the sun beating down through the yellow hat cast a golden glow on the man's face.

This old Spanish woman was photographed in open shade in very low light on Ektachrome pushed to ASA 800. Pushing the film emphasizes the cool tones, as do the low-light/open-shade exposure and the fact that her face fills most of the frame, reflecting the coolness of the shade.

inside a café, for example, and are likely to provide some great candid opportunities. As a photographer, you will seem less obtrusive, and your subjects will be less self-conscious. In dim light, colors seem more saturated and richer. Shadows are softer, distracting areas of sharp contrast are evened out, and the mood and atmosphere are clear.

Look for areas or shafts of light that pick out and isolate the subject by acting as natural spotlights (you may need to switch to a faster and/or tungsten-balanced film). A fast wide-angle lens will help you make the best use of the light and is also extremely effective for de-picting cramped interiors. Avoid the use of flash; the harsh light, extra paraphernalia, and intrusive quality of a flash unit will only destroy the moods you seek to capture. Learn to take advantage of the existing light by developing a steady hand for long, hand-held exposures. Many camera shutters are relatively noisy at slower speeds; if this creates too much attention, set your camera on a soft surface, such as a sweater, to absorb as much sound as possible.

A room without any windows is a rarity. In a room with windows, during the day at least some natural light is

The hot Portuguese sun on this ochre-colored wall at noon made the scene clear-cut and sharp. The high-contrast portrait of the man and boy came from taking the light reading off the bright wall, which resulted in an underexposure of the jet-black interior and shadows while saturating the colors of the people. An 85mm lens was set one full stop under the ''correct'' exposure for Kodachrome 64.

Bright light on white walls was the visual appeal of this small Spanish mountain town. A mixture of open sunlight and light shadows was the problem in the background of this photograph of a woman descending the stairs. The reading was set for the light shadows to preserve the high contrast of the details. The slight compression effect on the masonry is the result of the medium (135mm) telephoto.

This young boy represents a kind of formalized outdoor portrait. The diffused light of a cloudy-bright winter day was reflected by the white snow back onto the face of the subject, while the background was thrown out of focus, but not totally, by an intermediate f-stop setting using an 85mm lens and Fujichrome film.

almost always present indoors. If the light comes from a large window, it will be fairly even; but if it comes from a small window or narrow doorway, the situation gets trickier. Light will fall off sharply as your subject is further from the light source; and so a room brightly lit at one end from a small window could be dark and shadowy at the other end, creating a contrast range that could spread over six or seven stops. There is sometimes no simple solution to this, and you must resign yourself to losing a lot of detail through over- or underexposure. To preserve detail in the darker areas and avoid overexposure in the light areas, the best compromise is to meter both extremes and choose an exposure somewhere in between. (To be on the safe side, bracket one stop in either direction.)

If you are indoors looking out from a dark interior to a bright outdoors scene, you have two options. One is to silhouette your subject against the light. Bright, diffuse light makes an ideal backdrop for silhouettes. If the subject is only a small part of the scene, expose normally. If the subject is larger or is much lighter than the background, use a slight underexposure. Alternatively, use the doorway (or window) as a frame, and set the exposure for the outside scene. The interior will be dark and frame the scene.

INFORMAL PORTRAITS

The most vibrant and insightful portraits are often candids, where the photographer has captured a moment of animation or repose without the subject's knowledge. But some people enjoy posing for the camera. They are "naturals" who stand out in a crowd, know the pose they want to give you, and exert all their charm to deliver it. For other people, posing for pictures is part of their job. Department-store Santas, amusement-park characters, costumed staff at historical sights, ceremonial guards—

In this Greek taverna, the window light was strong and the men were back lit. The light reading was taken off the man on the left, since he was not in the direct path of the bright light streaming through the window. A general light reading would have been unhelpful in this situation because it would have silhouetted the men and given an accurate color rendition of the scene outside the window, distracting from the interior scene. The intimacy would have been lost. Here instead, the window light serves as a pure white backdrop for the scene. Because of the low light levels and slow film (ASA 25), it was necessary to use an exposure of ¼ second.

Another photograph in the same taverna was shot with the same 35mm lens, but this time as a portrait. The side light of the window was used to highlight the face. By moving closer and changing the angle of view, the same bright light of the photograph at left has now been used to dramatize warmth, diffused as it is, but able to illustrate texture. The meter reading was taken directly off the man's face; because of the low light level a saturated tone becomes the dominant color balance in the picture. The close working distance combined with a wide aperture produce a wide-angle version of selective focus.

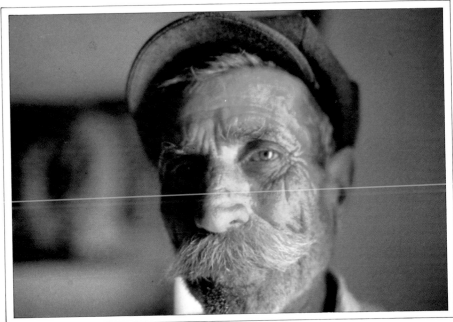

part of why they are there, after all, is for you to take pictures. Don't dismiss them as touristy clichés; instead, look for interesting ways to take the shot. Keep an eye out for the revealing detail, the unusual angle, the comic juxtaposition or anachronism.

A dark, open doorway in Spain provided the setting for this portrait of a young girl and her grandmother. Selective focus has balanced the composition, while the shot was slightly underexposed (one-half stop) to darken the background as it picked up the light color in the little girl's dress. The largest lens opening was used to throw the grandmother out of focus while keeping the attention on the girl. The film was Ektachrome 400.

GROUPS

People constantly form into groups for any number of reasons, from the chance group that forms at a bus stop to the highly organized group of a symphony orchestra. When photographing any group, you must show why it exists; otherwise the picture shows only an aimless collection of faces and figures.

For candids of groups, position yourself to get mostly faces, not backs, into the shot. Wide-angles get a lot of people into the frame, while telephotos flatten and compress a crowd, making it seem larger than it is or emphasizing its size.

Posed group portraits are often needlessly stiff and awkward. Select a background that is evenly lit and uncluttered,

A cloudy day at the Stratford-on-Avon fair in England provided the background for this quick shot of a child working in one of the booths. This child was a ''natural,'' and made photographing him a simple act of focusing and shooting. The skin tones are soft because of the overcast day. A 50mm lens was used with Ektachrome 400.

This child was walking through the field when some birds took off a few feet away from her and she turned to watch them. One flew back and landed, catching her attention and creating a memorable shot. The exposure was a split reading between the open field and the child, which caused a slight green cast from the slightly overexposed scenery. The film was Kodachrome 25; a 50mm lens was used.

Portrait candids are where you find them. In this photograph, the little boy and girl were standing on the side of a rural road in Portugal under the broken shade patterns caused by the bright overhead sun through leaves. They were distracted, allowing this close-up shot to be taken virtually unnoticed. For a broken-pattern light reading, the neutral tones of the hand can be used to get the correct exposure. The film was Kodachrome 25 shot through a 35mm lens.

and then try to arrange the group so that one person is the dominant figure and the others play supporting roles. The dominant figure may be chosen by virtue of personality or simply because the colors involved make him stand out. You don't need to become an officious stage manager, though; the group will often sort itself out naturally into an order. In fact, you'll probably even get some good candids if you shoot while this is going on. Position yourself so that the group fills the frame without a lot of empty foreground. Make something of a show of taking the "official" picture, and then casually snap some shots as the group relaxes and starts to break up. It's an old photographer's trick almost guaranteed to produce some revealing photos.

CHILDREN

The same rules of courtesy that apply when photographing adults extend to children. Respect them as people, not as photographic props. Children may be initially frightened of a stranger with a camera, so your first step is to put that

133

This shot was taken in London in morning light, crisp and clear, in October. The little boy had been following the parade while riding on his father's back. Several exposures of that didn't seem satisfying somehow; but sure enough, when he was put on the ground he started marching on his own, in his own parade. A very wide-angle 18mm lens gave the picture its unique perspective.

The overwhelming greens of the forest and the hazy, diffused light of the day gave this military park in Holland a flat but pastel-saturated mood. With a predetermined exposure set, the photo was taken quickly and easily when the child approached the huge tank. Shot with a 105mm lens and Kodachrome 25, the scene has its depth heightened by the contrasts of light and dark.

134

fear to rest: show them that you are interested and harmless. Kids love to laugh, so be a comic when they meet you and your camera.

Because children are the way they are, you must work quickly and make snap decisions when photographing them, but this does not mean that you can be haphazard. Some advance planning is crucial. Scout possible locations in advance. For example, a playground may be empty at midmorning because the children are all in school, but buzz with activity in the late afternoon. Look the playground over and anticipate what the afternoon light will be. Plan good locations for unobtrusive candids. Then, when the children arrive, you can concentrate on taking pictures.

Children move quickly, and their expressions and emotions are often fleetting. Always try to have a fresh roll of film in the camera, so you don't miss an opportunity because you're changing film. Don't wait for the perfect picture to appear: take the chance that a shot may have an area out of focus if it means capturing a radiant smile.

Get down to the child's level—kneel, sit, crouch, or even lie flat. This will give you the eye contact that makes a picture come alive, rather than a picture of the top of a child's head. Use a wide-angle lens, and get in close.

Most children today have been regularly photographed since birth, and so have a sophisticated awareness of the camera. Your biggest challenge is keeping their self-consciousness at bay, and

all the ways of doing this basically come down to establishing a rapport. Use their favorite toys or games to distract them and capture a natural pose.

THE GRAB SHOT

Every now and then, everything seems to be just right and the "one chance only" photo situation appears and is caught. To the photographer, this is the most rewarding picture to get. It means everything was perfect: the lighting, the color, the subject, the lens, the exposure, the luck. Of course, as an observer you must be prepared for a fast-breaking photo situation. Your eye must be on the prowl and your camera should be ready for anything, especially when you are walking through public places like parks or carnivals, places where people pictures appear and then disappear in seconds. Sometimes, if you're lucky, the preconceived notion or concept can be accomplished by finding subjects and following them until they seem to fit the part you've been trying to assign them.

Another type of grab shot is the turn-around-and-fire kind. You can only hope that one or two of your photographs will capture the magic moment.

Candids and portraits, events and interpretations, are all parts of the larger concept of the whole, a stimulating visual impression. This doesn't come easily, but practice and patience help. What Louis Pasteur said of science also applies to the art of photography: "In the fields of observation, chance favors the mind that is prepared."

7
Outdoors and Travel

PHOTOGRAPHY IN THE FIELD CAN BEST BE described as planned luck. It is luck in the sense that location shooting depends on the photographer being in the right place at the right time; but planning will help ensure that he is, and technical and aesthetic skill will ensure that the shot is a good one. Some pictures, of course, just happen, and being ready and able to react quickly and correctly to any given situation is the mark of the truly skilled photographer.

TIME OF DAY

Most people are aware that the sun rises in the east, is overhead around noon, and sets in the west. They are also aware that days are short in the winter and long in the summer. But as a photographer, you need to be more exact in your understanding of how light changes with the seasons and the times of day.

Seasonal light. The light of the seasons varies from place to place depending on latitude. Near the equator, there is little difference in the sun's position throughout the year; near the poles, on the other hand, the seasonal differences are greater. In the limited discussion that follows, the suggestions offered are aimed primarily at anyone photographing in western Europe, Canada, and the northern United States.

In the spring and autumn, daylight lasts for about twelve hours, with the sun at its brightest between 10 A.M. and 2 P.M. and an hour of twilight at dawn and dusk. At its highest point, the sun's ele-vation is about 40 degrees above the horizon. During the summer, daylight lasts longer, from about 4 A.M. to 8 P.M., and the twilight of dawn and dusk lasts for about two hours. Summer sunlight is at its brightest between 6 A.M. and 6 P.M., with the sun at about 60 degrees above the horizon at high noon.

Days are short in the winter, lasting from about 8 A.M. to 4 P.M. At its highest, the sun is only about 20 degrees above the horizon; at its brightest, the color temperature of winter daylight is only about 4,500°K. Dawn and dusk are brief, lasting less than an hour.

Time of day. Very early in the morning, the sun's light is low, slanting across the scene and producing long shadows. The sun is still on the horizon, and because the blue wavelengths are scattered by the atmosphere, the light tends to have an orange cast. Shadows will tend to retain the blue of pre-dawn, however, and morning mists may give an overall cold blue cast.

Low sun is good for stressing shapes and colors, and for creating silhouettes. For shapes, position the camera to one side of the sun, and use the resulting strong cross-lighting to bring out strong shadows and shapes. Place the sun behind you to get front lighting with good color saturation and low contrast. For silhouettes, face the sun and expose for the sky. The high contrast of the lighting will silhouette the foreground. It may also cause lens flare. Rather than avoiding this, try incorporating it into the

This red roof and blue sky in Quebec show the clear and well-defined colors of afternoon, when the brilliance of light is aggressive because of the amount of ''white'' light that reaches the subject. This was shot with a 200mm lens on Kodachrome 64.

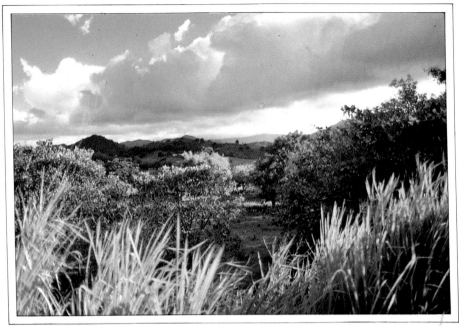

Available light that covers a large area is shown in this vista of a valley in Puerto Rico. The changing cloud patterns and bright, open sun streaks create depth, while the light brings out the various elements in the picture. The direction of the early afternoon sidelight was so intense that it became the key element of the photograph. The feeling of depth was enhanced by a 35mm lens at f/16, shot on Kodachrome 25.

picture for an extra creative touch. The light of dawn changes rapidly, so keep an eye on your exposure meter.

By midmorning, dawn mists have generally burned off, and direct sunlight is hitting the subject, creating shadows and contrast. Colors are less subtle and details less apparent, but picture possibilities are still all around. Move in for details.

At high noon, the shadows are hard and short, the light harsh, and contrast levels high. Don't fight the light; use it to take powerful shots of strong graphic shapes and contrasting colors. A polarizing screen will greatly help reduce glare; in addition, an amber filter such as an 81B may be needed to balance the bluish cast of the shadows.

As the afternoon wears on, shadows soften and lengthen and colors warm up, and by late afternoon the blue of

the sky lightens and begins fading into orange. The light is gentler, but polarizing screens may still be needed. As the sun gets lower, its light contains more red wavelengths; light-colored objects will start to take on a pinkish tint.

The basics of shooting sunrises apply to sunsets as well. In fact, it is often difficult to distinguish between shots of the two. Glorious cloud formations lit from below the horizon occur at both times. Check the exposure meter constantly as the light fades away, and remember that reciprocity failure will occur during long exposures.

Pictures of the moon are less complex to take than they may seem. Since the moon reflects the sun's light, it is actually quite bright and can be shot at fairly high, hand-held shutter speeds. For an accurate color rendition, use daylight

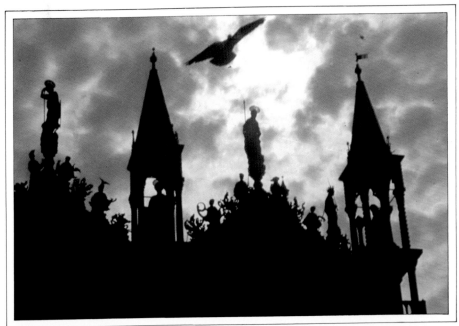

Dark storm clouds were moving over the Cathedral of San Marco in Venice; the light reading was from the bright sky. Only one quick photo of the pigeon was possible as it flew across the viewfinder. The patchwork of the contrasting clouds and cathedral towers was produced by an underexposure of two full f-stops to make a "black-and-white" color rendition. A 200mm lens was used with Ektachrome 400.

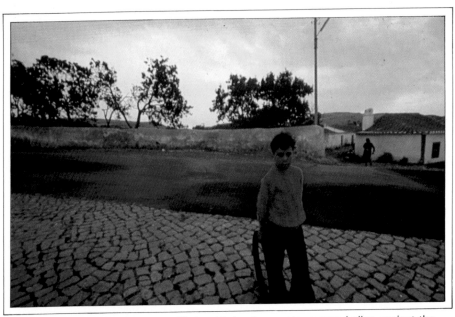

On a stormy day in a Portuguese village, this boy's sweater seemed alive against the billowing clouds. Although the bright color of the boy is special, it is not the only element. The old woman dressed in black against the white wall in the background is also important to balance the composition. A 35mm lens and Kodachrome 25 were used.

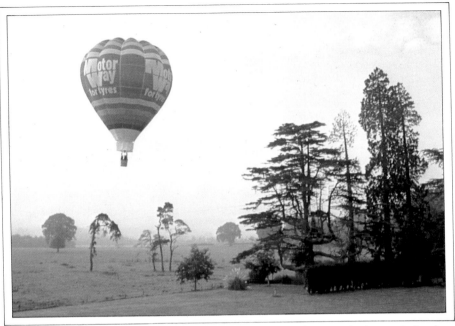

An eerie morning landscape, shrouded in mist, was being photographed as a study of low-key color in rural England, when a balloon punctuated the quiet solitude of the scene by descending into the picture area. The composition and exposure were already set and several frames were taken with a 200mm lens and Kodachrome 64. A photograph that began as a study of mystery became one of comic incongruity.

film. Shooting by moonlight can involve long exposures of several minutes or more, so choose an unmoving subject; here, trial and error is the only exposure guide. With ASA 160 film, try starting at 15 seconds at $f/2$, and bracket. Tungsten film will give you the bluish cast many people associate with moonlight.

WEATHER

There are no ideal weather conditions for picture taking. The colors of wet days or overcast and cloudy days, or the monochromes of hazy or snowy days, produce their own particular moods and photographic possibilities. It may feel more comfortable to stay at home or in the studio when the weather is bad, but with a little extra effort, you can venture out, face the elements, and record the dramatic pictures these days offer.

Cloudy days. Cloud cover creates a diffused backdrop, with muted colors and flat light. The effect depends on the type of clouds; a heavy black overcast can reduce the brightness level by several stops, while a light, high layer of clouds will give a diffused light with distinct shadows and fully saturated colors. Since clouds generally act as reflectors by softening shadows, they create the ideal light for good pictures, especially of people.

On overcast days, the sky is gray and can appear washed out or blank in the picture. Although you may occasionally want this effect, it is often better to compose the shot so that you eliminate as much sky as possible. Even an overcast sky is still bright enough to fool the meter into underexposure; open up a half stop or so and bracket your shots.

As the clouds get heavier, colors become more intense and the light gets more variable. At the same time, shadows and contrasts get softer or even disappear as the clouds diffuse the sunlight. Check exposures carefully, because the light may change rapidly as the heavy

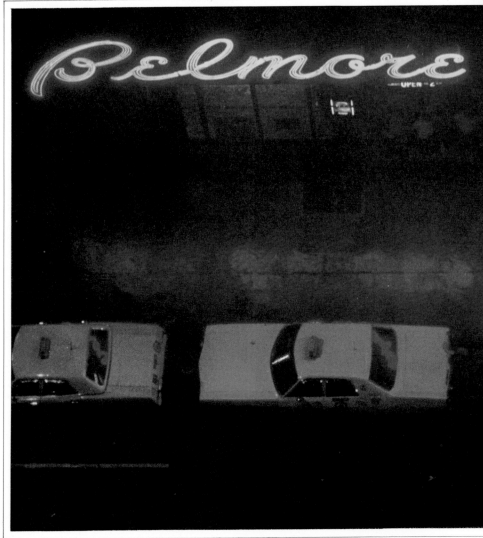

This scene was shot in the rain using Ektachrome and a 105mm lens. The neon light was heightened in brightness by the bright yellow of the slick-surfaced taxis, while the gaps of darkness between the wet red reflections of the sidewalk and the street are the result of the direction and quantity of available light reaching the taxis, making them appear considerably brighter than usual.

clouds of an approaching storm roll in.

In themselves, the dramatic clouds of a thunderstorm or the golden clouds of a sunset can be intriguing photographic subjects. To help orient the viewer, include a horizon line in the picture. A wide-angle lens offers increased coverage. Polarizing screens increase saturation and contrast; avoid underexposure caused by the meter compensating for a bright sky.

Haze, mist, and fog. Although they are meteorologically distinct, haze, mist, and fog create similar problems for the photographer by reducing contrasts and muting colors into near monochromes. Only close objects are distinct; the rest merge into the distance, adding a sense of great depth because of aerial perspective. It is difficult to judge distance in misty conditions: if all the important parts of a picture are at a distance, they will all seem to be on the same plane.

Haze and mist are often found near water early in the morning, although haze also occurs at high altitude. Over long distances they scatter the ultraviolet light, often causing blue color casts in the picture.

When shooting in hazy or foggy light, look for strong shapes that can stand on their own or as silhouettes. The light may seem subdued and dim, but it is actually fairly bright and it may trick the meter into indicating an underexposure. Expose carefully, taking the reading from a gray card, the palm of your hand, or a middle-gray tone in the scene. Still, to be on the safe side, bracket your exposures.

Rain. A few drops of water, quickly blotted away, won't hurt your camera, but before you go out into the rain, take a few simple protective measures. Wrap a clear plastic bag round the camera, holding the mouth of the bag around the lens with a rubber band. Place a clear glass or ultraviolet filter over the lens, and use a lens shade. If condensation

Droplets of rain serve to further diffuse the forms and shapes of this scene. Ektachrome 400 and a 50mm lens were used; the point of focus was the car. Since the car was the main subject of the photograph, its sharpness was crucial.

forms inside the plastic bag, discard it, immediately dry off the camera, and put on a dry bag.

Light rain and drizzle create much the same effect as mist and fog, and most of the same principles apply. Rain at night makes normally dull surfaces reflective, and makes reflective surfaces even more so. By day, colors are muted by rain, and there tends to be a bluish cast to the light.

A heavy rainstorm can be highly dramatic to those present yet appear strangely static on film. Try to shoot pictures that really show the motion of the storm —trees blowing in the wind, whitecaps on water, and surging, billowing clouds. Difficult as it is to create a sense of falling rain, with some thought, it can be done. For instance, try using back lighting and a slow shutter speed to create a blurred effect, suggesting a downpour. The most exciting part of a storm is often as it gathers or breaks up, the points when the light will change rapidly as the sun is blotted out or breaks through the clouds: watch for potential pictures and work fast. Keep an eye on the exposure meter, and bracket your shots.

If you are lucky enough to see a rainbow, don't waste time, because they vanish quickly. Try to put something interesting in the foreground to provide a sense of proportion for the viewer, and take the exposure reading from the foreground, not the sky. A slight underexposure will, of course, give better color saturation.

Snow. Falling snow is basically similar to falling rain in terms of reduced contrast and blurry images. A fairly rapid shutter speed (1/125 second or more) is needed to freeze falling snowflakes. Expose normally; the dark sky will balance the white, reflective snow in the meter reading. In addition to protecting the camera from moisture, try hard to keep it relatively warm. Battery falloff from any

In this early-morning snowscape photographed on a winter's beach, the snow-covered dune is pastel-colored and the browns of the twigs are brisk. Well-outlined patches of brown and white texture in the left foreground balance the frame. The light reading was off the sky; a 20mm lens was used. On super-bright days in large, open areas of snow, overexpose one to one-and-one-half f-stops to assure an accurate rendition of the snow.

The distinct features of the Hawaiian coast, the inclusion of foreground detail, and the acceptance of the natural atmospheric haze on the horizon give this seascape a feeling of great depth. A 28mm lens was used at an angle level to the film plane to keep the horizon line straight. The composition is based on two massive color shapes (the sea and green coast), with the horizon placed near the top of the frame to enhance the feeling of distance.

extreme cold will cause inaccurate meter readings at the least and will affect all battery-powered functions of the camera as well. In very cold, dry weather, film can become brittle; cock the shutter slowly and evenly to avoid either snapping the film or creating static marks. In addition, abrupt changes from cold to warm will cause condensation on and in the camera, and could cause serious damage. Warm the camera up gradually when coming in from the cold and wipe away any moisture.

To add interest to a snowy scene, choose a time and angle that will bring out textures, highlights, and shadows. Side light and back light are good for this, and the long shadows of late afternoon will also give warmth and color to the scene. The crisp, clear light of early morning will give amber tones, with light blue shadows, while late evening light brings blue and purple tones to the snow that will be accentuated by the

The bright, aggressive colors of the foreground flowers traveling diagonally across the picture area are, in this view of the Amalfi coast in Italy, visually overpowered by the white contrast of the diagonal line that intersects it from the middle left of the scene. The dynamic angle is further intensified by the strong blue line where ocean and sky meet. A 24mm lens was used at f/16 to increase depth. Because the horizon line is only a small portion of the picture, it is in the center and is used as a stable symbol in a photograph dominated by advancing whites and reddish colors. It was shot on Kodachrome 25.

In this seascape in Puerto Rico, the horizon line was placed in the upper third of the frame so that the proportions of the scene would stress great distance. A polarizing screen and a 24mm lens were used at a fast shutter speed to saturate the colors and stop the motion of the waves.

Man leaves his mark in nature, as shown in this shot of the gray mass of the sign. A tranquil lake is now translated to a symbolic, abstract view. The strong diagonals of the picture contrast with the placid vanishing point in the distance even as they heighten it. The photo was taken with an 18mm lens and Kodachrome 25.

This fjord in Norway is an example of a moodscape. The composition shows equal portions of the sky and its reflection to emphasize the overcast, low-hanging, cloud-draped environment. The blue tones and gray mists of the picture and their reflections in the deeper blues of the water, combined with the telephoto effect of a 180mm lens, give the picture a calm and cool cast. The atmospheric haze softens the colors of the scene, while the advancing light-gray cloud gives the picture a three-dimensional effect.

The open-air effect of winter landscapes can be seen in the bare trees that leave the view unobstructed. The angle of view and the 18mm lens give expansion to the scene. The water leads the eye to the imaginary horizon or vanishing point; its diagonal angle also gives motion to the picture.

reciprocity failure due to long exposures.

Snow and ice are obviously highly reflective, and so a polarizing screen to reduce glare and bring out color, especially if you must shoot in a harsh light, is useful indeed. Since snow can distort an exposure reading, particularly on a bright day, meter from a gray tone in the picture, or use a gray card. Even at that, be aware that the possibility of an underexposure is great.

LANDSCAPES

All good landscapes have a center of interest, but because of the different ways that the eye and the camera see, it is up to the photographer to look at a scene and find the vantage point that will illustrate a representative part of the landscape or one that shows its most important feature or one that simply has the most pictorial interest. Naturally, considerations that go into any good composition apply to landscape photography, but two factors are particularly important here: placing the horizon and perspective.

Horizon. The distribution of visual weight in a picture depends largely on where the line of the horizon is placed. It is the first decision to make in simplifying the scene, eliminating unwanted objects and space, and determining the placement of foreground and background. Except in cases where the foreground and background both contain areas of equal importance, the horizon should never split the frame in half. Continually placing the horizon at eye level will give an overall sameness to your picutre. Vary the angle of view. A low angle is a little unusual and stresses foreground details; a slightly high angle will also include the foreground, but from a slightly compressed perspective.

Perspective. A convincing portrayal of depth, crucial to the success of a landscape photograph, can be gotten by using normal or aerial perspective and the horizon line. In normal perspective, objects get smaller as they recede away from the camera and toward the horizon, and their diminishing size gives an impression of distance. By showing colors that fade or are lost in mist as they recede into the distance, aerial perspective also creates a feeling of spaciousness. Ultraviolet filters, on the other hand, reduce distance haze; along with polarizing screens, they increase contrast and color saturation instead, so don't use them to the point of destroying depth in the scene.

By placing the horizon toward the bottom of the frame, the picture is filled with sky. This can create a powerful feeling of loneliness or isolation, and is an excellent way to show dramatic sunsets or weather conditions. Conversely, a horizon line toward the top of the frame leaves a lot of room for foreground elements and suggests great distances, particularly when combined with a low camera angle.

The use of foreground in a landscape need not be limited to sweeping angles, depth symbols, or exaggerated perspective for spatial effects, since it can also be used as a design element of form, shape, and color, creating a picture within a picture by its placement and interest. At the same time, foreground details can strengthen the impression of depth, and tie the background and foreground together. Normal or wide-angle lenses, set at their smallest apertures, give the depth of field necessary for this.

The seasons. A major function of landscape photography is to show the character and changes of the seasons. Such shots can easily turn into clichés, however, and the creative photographer must learn to see the individual subtleties of the seasons.

Winter landscapes, for example, are often thought of as white with snow, but that is only one type of winter. Snow gives the photographer wonderful shad-

The golden palomino horse is the main shape in this photograph; the abstract shadow on its back is used as negative space to break up the even tones of the rest of the photo. The division of space in this picture and the large image size of the horse that fills the frame give the picture a dual compositional role, creating a picture within a picture. It was shot with a 28mm lens and Fujichrome 100 with a polarizing screen.

ows and textures to work with, and is a good background for close-up detail shots as well. Partially covered branches, fences, and so on offer endless compositional possibilities, since in reality the proverbial blanket of virginal white is fairly uncommon. Much more likely in a winter scene are cold tones of brown, gray, and blue. Evergreens, bar branches, ice and icicles, and snowcapped mountains are strong symbols of winter. The stark absence of foliage in the winter will make geographical features stand out sharply.

Spring means green to almost everyone, and the freshness of new leaves, grass, and flowers brings a strong emotional response, one you must seek to capitalize on and capture. The light of spring is warmer and the days longer than in winter, but the heat of summer

is yet to come so you should look for scenes that show these intermediate qualities: landscapes that show the drab colors and harsh shapes of winter being brightened and softened by spring's pastel shades. Juxtapositions, such as early flowers in a spring snowfall, will evoke this feeling strongly.

In summer, foliage is at its fullest and greenest, and the days are long, bright, and hot. Landscape shots can all too often turn into dull vistas of green leaves; look for variety. Take advantage of the season's characteristics, like lingering sunsets and the dramatic skies of sudden thunderstorms.

Rich color of every description, combined with clear air, makes autumn a photographer's favorite season. Landscapes seem full of vibrant color in almost any type of lighting. Autumn days

are shorter, with abrupt sunsets. A tripod is useful at this time of year.

The gray clouds of a dull autumn day make a good backdrop for the warm colors of the foliage. Overall diffuse light mutes the colors; on the other hand, back light and angular side light cause foliage to come alive. The characteristic haze of autumn is excellent for adding a touch of aerial perspective to the scene, especially in hilly areas.

Seascapes. When you are looking out to sea, the horizon evokes infinity, regardless of the lens being used. Since the line itself is usually unbroken, interest in the composition must come from the foreground or background elements. The natural curves of reefs, beaches, and rocky shorelines can be interesting, while setting or rising suns, along with the clouds they illuminate, often seem exceptionally dramatic in seascapes. For a sweeping vista with a small sun, use a wide-angle lens; for a compressed effect with a huge sun disk, use a telephoto. Side light and back light bring out the texture of the water, and if you underexpose by a stop or so, you'll capture patterns of specular light glinting off the surface. For pseudo-moonlight effects, underexpose the shot by several stops, and the scene will be dark with glowing specular highlights.

Don't neglect the shore, either. Sand will glitter and dunes will cast dramatic shadows in strong side light, and natural still-lifes are found all over the shoreline —in the small pools, in the foam, and on the sand, the rocks, and the reefs.

While photographing on the beach or near salt water can be highly rewarding, it can also be highly destructive to camera gear. Both salt water and sand can do a great deal of damage by corroding metal and scratching lenses. A good way to avoid lens damage is to always use a lens shade and place a filter, even if it is just clear glass, in front of the lens: filters are, after all, considerably cheaper to replace than lenses. Use

The richly colored fall trees and the
contrasting houses were photographed in
upstate New York with a 135mm lens and
Kodachrome 64. The mountain foliage
was used for a color backdrop,
compressed and textured in light, against
the bright, advancing whites of the
houses at the mountain's base.

The rugged, sea-going fishing boat contrasts with the refined architecture of this coastal town in Normandy. The morning light brings out the highlights of white houses against the blue canal and sky. A vertical format was used to narrow the angle of view to an isolated picture area that stresses the contrasts between the foreground subject and the background, emphasized by the perspective effects of the 200mm lens. Kodachrome 64 is the film.

The elegance of a Florida mansion, framed by palm trees and a deep blue sky and sitting restfully on a graceful compositional curve, gives this exaggerated view of the classical estate an air of grandeur. A polarizing screen was used to darken the blue sky, remove reflections from the water, and intensify the clean whites of the masonry and building. A 24mm lens and Kodachrome 25 were used.

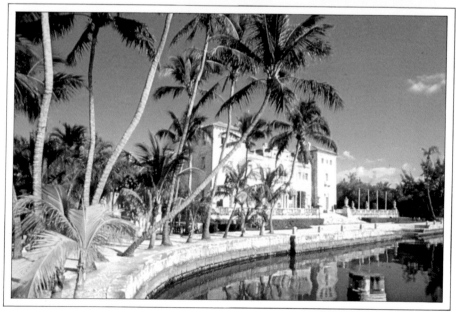

a plastic bag to keep out spray and sand, and clean the camera thoroughly after each day's shooting.

If you are shooting in a tropical or subtropical environment, or in any hot, humid area, keep your gear as cool and dry as possible, since moisture will corrode metal parts, and fungus will literally eat away organic parts, such as the glue that holds lenses in their mounts, leather camera straps, and film. Store equipment in a dry place, preferably one that is air-conditioned, and use packages of silica gel to absorb excess moisture.

Mountains. The outstanding effects of mountain landscapes are often created with telephoto lenses, in part because mountain terrain is often otherwise inaccessible. The stacking effect of the telephotos emphasizes the geometric shapes

of mountains and also emphasizes the haze of high altitudes; though this is often useful for creating aerial perspective, it can also be excessive, causing colors to seem washed out. To reduce haze, use an ultraviolet filter, a polarizing screen, or both. If this doesn't help, either make the best of the situation, or consider returning at a more favorable time of day or season.

Early morning or late afternoon light is a good time for mountainscapes, since the light coming in from the sides helps form patterns and modulations of the scenery, adding depth and a three-dimensional feeling to the picture. High noon helps for detail shots of portions of the landscape but the overhead lighting doesn't really show the forms of the mountains. Late evening, when the mists drift into the

These two mountainscapes in Puerto Rico are examples of photographic variations on a theme. The compositional format for both is horizontal and both photos were taken from the same camera height and working distance, but the angle of importance is drastically different. The wide-angle view shows the sweep of the whole scene, including the grafitti-painted railing leading directly to the portion of the rain forest that is bright with color and light in the midst of deep grays and greens. The view goes on into the valley, taking in every detail before it. The 200mm view is totally different because it concentrates on the mountain alone. The gray cloud frames the upper third of the picture, and the jagged shapes of the dark landscape behind the bright patch combine with the sloping, curved shape of the medium-toned foreground to add depth to the shot.

A sweeping angle that forces the eye to look up contributes to the force of motion in this desertscape. A 28mm lens and a polarizing screen were used to heighten the contrast and saturate the golden rocks and earth in the light of late afternoon. The low angle picks out the shapes and shadows of the sun-baked rocks and uses them to balance the gray sky and white puffs of clouds. The film is Kodachrome 25.

valleys, provides a good chance to evoke a feeling of tranquility, and the use of light blue filters can further enhance the feeling of evening while adding a monotoned, contrasty effect.

Deserts. Deserts can be the source of color photographs that can take the sensitivity of the film to the very limits of its ability to reproduce color accurately, but with magnificent results. Desert mornings, late afternoons, and early evenings are the best times to shoot the broad range of color shifts, while sunsets and sunrises on the desert bring warm lights that turn the arid bareness into a painter's dream of warm pinks, oranges, browns, and golds through blues, purples, and deep blue-violets. The hot, strong sun can provide interesting but flat lighting in midafternoon, when the full intensity of the parched

desertscape can be seen in the strongly lit shadows and dry earth colors. Of course, the midday desert sun also makes it a bad time for any sensible photographer to be walking around. Early morning and late afternoons, though, when the sun is not as intense and the lighting and colors are at their best, are really the best times to take pictures, as long as you use a polarizing screen to reduce glare and reflections, and wear sunglasses when not actually shooting.

The fine dust and intense heat of the desert can destroy both cameras and film, so keep all your gear covered against the dust and as cool as possible. Never leave anything in direct sun, and never leave anything in a closed place, like a parked car. Given that film is highly sensitive to heat, you should keep it refrigerated both before and after

These houses at the base of the white cliffs of Dover were elongated and made to reach toward the cliffs by tilting the wide-angle lens, which leads the eye to the top of the frame. The converging lines of the houses, with their flat rooftops, contrast with the undulating shapes of the cliffs themselves. A polarizing screen darkened the sky to a blue-black and brought out the contrast of the whites in the scene. A 24mm lens was used with Kodachrome 25.

exposure if possible, and in an ice chest or cooler if no refrigerator is available. Camera and lens should be protected from dust and sand with a clear plastic bag, a filter, and a lens shade. Even with all these precautions, clean the camera thoroughly and often.

TRAVELING WITH YOUR CAMERA

The more you research and plan your trip, the more likely you are to bring back great pictures. Literature and history books tell you what the places you plan to visit mean both to the people there and to the rest of the world. Guidebooks describe the highlights; list local events; and give maps, suggested itineraries, and information about lodgings, historic sites, and museums. Bring along a phrase book if you don't know the language. Government tourist offices are very helpful, providing up-to-date information about such things as customs regulations and recommended health precautions.

To avoid problems in international travel, check up on the customs regulations of the countries involved. Register your equipment when necessary, and carry the invoices that show where it was purchased.

When traveling with photo equipment, professionals always try to travel light, but light is a relative term. Think carefully about where you are going, how long you will be there, what equipment you already have, what you can afford to buy, and how strong your back is. A basic lens system would consist of a moderate wide-angle, a normal lens, and a medium telephoto, with matching filters, polarizing screens, and lens

shades. If you're off on a wildlife safari, say, you'll want longer telephotos. In short, adapt your gear to your anticipated subjects.

You'll need at least one camera body, and preferably two, both to save time-consuming lens switching and for a back-up if one body fails. You may also want to carry a tripod and cable release. Take twice as much film as you think you could possibly ever use. Carry your gear in a strong case that holds it all compactly and firmly. Cases that are unmistakably meant for cameras can be an open invitation to theft, so try to find a bag that is fairly anonymous, and never let go of it unless it's to put it in a locked place. Never check your camera bag

through with the rest of your baggage: *always* carry it with you. When passing through airport security checkpoints, *always* request a hand search of your camera bag, and *never* allow your film to be X-rayed. Watching a security official fumble with your camera gear can be a trying experience, so offer to open the lens cases, film cans, and so on yourself; if this is refused, be patient.

Pictures en route. You don't have to wait for the plane to land to start getting some good pictures. Takeoffs and landings provide some excellent opportunities for aerial shots, and it's a good idea to request a seat near a window and forward of the wing, if possible. To avoid the plane's vibrations, hold the camera

A night exposure was used to photograph the Alamo, in San Antonio, Texas. A tripod made the two-second time exposure with a 20mm lens possible. The camera was placed close to the structure, low to the ground, and was aimed upward. Ektachrome 400 (daylight) reacted to the color balance of the lights, which was closer to that of tungsten film, to create the golden cast. The shot was deliberately underexposed by one-half stop.

The Arch of Titus and the Coliseum in Rome were photographed from the Roman Forum in this shot. The arch was used as a framing device and as an important foreground subject. The camera was angled to make the most of the curves of the arch and the shadowed interior (negative space) in the design. A 35mm lens and an underexposure of one full f-stop increased the saturation of the Kodachrome 25 film.

firmly and don't press it or your body against the window or the wall. The windows of an airplane are usually made of a polarizing material, so a polarizing screen isn't necessary.

Shooting from moving vehicles, such as buses, boats, and trains, takes timing and luck. Grasp the camera firmly and don't lean against anything that will transmit vibrations to the camera. Wait for a steady moment, and use a fast shutter speed.

Fresh interpretations. Absorbing the visual characteristics of an area, its architecture, predominant colors, light, and daily activities, will attune you to the environment. One photograph — a panorama at dawn, a child in a street, a small café — can sum up an entire locale. Whether that view is a small, isolated close-up of a detail or a wider angle shot of a vast expanse, it should contain at least some of what you feel is typical of its ambience.

Finding the right spot to shoot from can take hours of walking, but this type

Sunset can be the best time of day to photograph landmarks, as with this sunset on the Acropolis, taken with a 180mm lens and Kodachrome 64. The Erectheum is the obvious center of interest and is balanced against the brightness of the sun by making the statues a strong silhouette. The main subject is the dark shapes in the foreground. The mountain range is the mid-point and the sun disk is the farthest point of focus.

of legwork can also reward you by leading to interesting and unexpected vantage points. Well-known sites and monuments can be transformed into fresh vistas if you can create fresh and unique visualization of scenes that have been photographed over and over again. So, choose a different angle of view, or make a time exposure, or try unusual framing devices to enliven your view of an oft-photographed place. Look for the light and time of day that will add to the overall appearance of the site, and find ways around the negative aspects of certain lighting. Don't settle for the sort of postcard shot sold in concession stands and tourist shops.

Museums and interiors. Different museums and historic buildings have different policies on photography. Many allow personal picture-taking by available light only; practically all forbid flash, and many forbid tripods. To avoid disappointment and unpleasantness, check in advance. If you can take pictures, bring high-speed film (both daylight and tungsten) and fast lenses.

Just as with frequently photographed monuments, famous works of art must be shot creatively to be anything more than snapshots, so search for unusual perspectives and fresh approaches. Remember as well that sometimes people looking at paintings are more interesting than the paintings themselves.

Interiors also can pose some special problems of their own. Daylight film will probably come closer to matching the color temperature of lights in most art museums and historic sites, but tungsten film may be the better choice in other places, especially at night. Use a wide-angle to open up crowded interiors; telephotos are rarely helpful for indoors situations. A high camera position also gives wide coverage of an interior.

To show decorated walls, you may have to tilt the camera, which will cause some convergence of the vertical lines

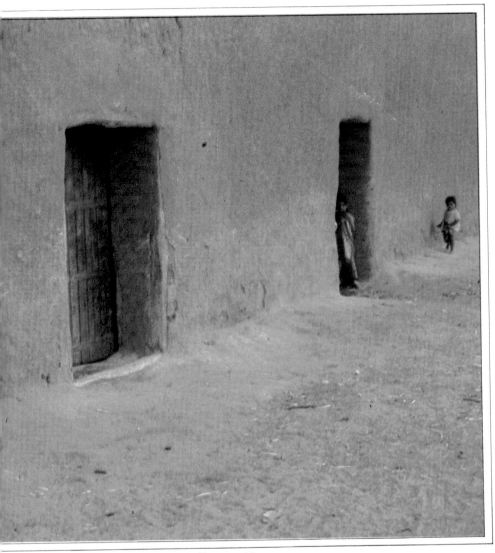

How to add color for effect is illustrated in this picture of a small village street in Morocco. The light was poor; the color seemed washed out because a large building blocked most of the light from the subject area. A color-compensating red filter (CC30R) was used to give an overall color cast to the scene and warm it up, adding a somewhat exotic feeling. A 28mm lens and Kodachrome 25 were used.

Although the Pyramid of the Sun in Teotihuacan, Mexico, is near a group of related structures, it was photographed as an isolated structure, the only center of interest. The angle chosen, the 24mm lens, and the vertical format make the ancient Indian structure the only compositional concern. Shooting at a low angle, the grass becomes a textural foreground. A deliberate "leaning" of the entire composition was used to give the illusion of depth and size, and an underexposure of half a stop and a polarizing screen were used to deepen the colors further.

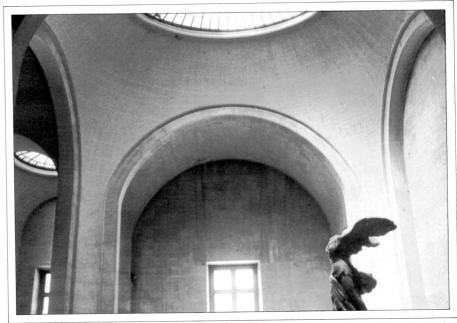

This photograph of *Nike of Samothrace* in the Louvre in Paris is an example of high-speed daylight film and a 50mm lens being used in available daylight. The skylights and windows have provided enough light to take the shot. Disturbing foreground elements were eliminated by moving the camera angle slightly upward, while the background was balanced in the exposure by metering from the middle tones.

which can be corrected by using a perspective-control lens, a piece of equipment few photographers own. A small amount of convergence is barely noticeable, and in fact is similar to what the eye sees when looking upward. Alternatively, exaggerate the convergence for dramatic effect.

There are some places where photography is forbidden, often for no apparent reason. Sometimes a smile and a pleading look will get you special permission to shoot, and sometimes permission can be arranged in advance. If it is refused, and if you have a quiet camera and are adept at concealment, you can try for some surreptitious shots, but be prepared to hand over the entire roll of film if you are caught.

Traveling with your camera is a rewarding way to get beautiful and meaningful pictures, but it's not the only way. Great pictures are all around you, in the extraordinary colors of ordinary life, just waiting to be seen through your increasingly skillful eyes.

Glossary

Aberration. A fault in a lens causing a distorted image. Modern lenses contain few aberrations. The most common kinds of aberrations are spherical, chromatic, coma, and astigmatic.

Accelerator. A chemical found in developers, usually sodium carbonate or borax, used to speed up development.

Acetic acid. An acid used in stop baths and acid fixers. It is usually used in diluted form.

Acid fixer. A fixer containing an acid, generally acetic acid.

Acid hardening fixer. An acid fixer containing a hardening agent, usually alum.

Acutance. An objective measurement of image sharpness, based on how well an edge is recorded in the photograph. An image with high acutance would appear sharper and more detailed than the same image with low acutance.

Additive color. Color produced by light in the primary colors blue, green, and red, either singly or in combination. Combining all three primary colors produces white light. Additive color is the principle behind color television.

Agitation. The technique of ensuring even processing by moving the film or paper within the processing solution, or stirring the solution itself.

Alum. A chemical often used in fixers as a hardening agent.

Angle of incidence. The angle at which light strikes a surface.

Angle of reflectance. After light strikes a surface, the angle at which it is reflected.

Angle of view. The widest angle of light taken in by a lens. On any lens, the angle of view is widest when focused at infinity; long lenses have narrower angles of view than shorter lenses.

Anti-halation layer. A thin layer found in film, designed to prevent light striking the film base from reflecting back into the emulsion layers and causing halation.

Aperture. The part of a lens that admits light, the aperture is a circular, adjustable opening.

Archival processing. A method of processing black-and-white film and prints to ensure that they will not deteriorate over time.

ASA. American Standards Association. The sensitivity of a film to light, or its speed, is measured by the ASA standard.

Autowinder. A motorized unit attached to an SLR camera to automatically advance the film and cock the shutter.

Available light. The existing light on the subject, whatever the source may be. This term is often used to describe a low-light.

Back lighting. Light directed toward the camera from behind the subject.

Barn doors. Flaps that attach to the rim of a photo light and can be adjusted to control the amount and direction of light.

Baseboard. The board on which an enlarger stands; any board used as a base for photographic paper.

Bas-relief. A photograph with a three-dimensional effect, created by sandwiching a negative and positive together slightly out of register and then printing the sandwich.

Beam splitter. A clear circle of glass used to simultaneously transmit and reflect a beam of light.

Bellows. A folding chamber, generally of light-tight cloth, between the lens and body of a camera, used to adjust the distance or angle between the film plane and the lens.

Bleach. A chemical bath that reacts with the black silver formed by the developer, either by dissolving it or converting it back to silver salts.

Blocked up. An overexposed or under-developed area of negative that prints as a light, undetailed area.

Bounce light. Light from an artificial source that is reflected onto the subject to give a diffused effect.

Bracketing. Making a series of exposures of the same subject, varying the exposure in increments around the estimated correct exposure.

Brightness. A subjective, comparative measurement of luminance.

Brightness range. The difference in brightness between the darkest and lightest areas of a scene or image.

Burning-in. The technique of giving additional exposure to selected parts of an image during printing.

Bromide paper. A type of black-and-white printing paper containing silver bromide in the emulsion and giving a blue-black image color.

Candela. The internationally recognized standard unit of measurement of luminous intensity.

CC filters. Color correcting filters, available in assorted colors and with densities ranging from .05 to .50.

Characteristic curve. A graph indicating the relationship between exposure and density for a photographic film.

Chroma. In the Munsell system of color classification, the saturation (purity) of a color.

Circle of confusion. A ray of light focused on the film plane registers on the film as a point. If the ray is not in focus, it registers as a tiny disk, or circle of confusion. If the circle of confusion is small enough, it will be indistinguishable from a point and the picture will be acceptably sharp.

Cold-tone developer. Paper developer that gives a blue-black color to the image on the photographic paper.

Color cast. An overall tint in an image, caused by light sources that do not match the sensitivity of the film, by reciprocity failure, or by poor storage or processing.

Color temperature. A system for measuring the color quality of a light source by comparing it to the color quality of light emitted when a theoretical black body is heated. Color temperature is measured in degrees Kelvin.

Coma. A lens aberration causing blurring at the edge of the image.

Combination printing. The technique of sandwiching two negatives together and then printing them.

Complementary colors. A pair of colors that, when mixed together by the additive process, produce white light.

Condenser. A simple, one-element lens found in enlargers and used to converge the light and focus it on the back of the enlarger lens.

Contact print. A print created by placing the negative(s) in direct contact with the printing paper. No enlarger lens is necessary.

Continuous tone. Reproducing or capable of reproducing a range of tones from pure black to pure white.

Contrast. The difference between tones in an image.

Contrast grade. A number indicating the contrast level produced by a particular photographic paper. The higher the grade on a scale of 0 to 5, the greater the contrast of the paper.

Cookie. A shading device made of a translucent material to give a mottled distribution of light.

Copper toning. Adding a warm, reddish-brown color to a print by using a copper-based toner. The long-term stability of a copper-toned print is not good.

Cropping. Selecting a portion of an image for reproduction in order to modify the composition.

Cyan. A blue-green color, the complement of red; one of the three subtractive primary colors.

D log E curve. A characteristic curve for a photographic emulsion, indicating the relationship of the density of the emulsion to the log of the exposure.

Densitometer. An instrument for measuring density.

Density. The ability of a developed silver deposit on a photographic emulsion to block light. The greater the density of an area, the greater its ability to block light and the darker its appearance.

Density range. The difference between the minimum density of a print or film and its maximum density.

Depth of focus. The distance the film plane can be moved while still maintaining acceptable focus, without refocusing the lens.

Developer. A chemical solution that changes the latent image on exposed film or paper into a visible image.

Diaphragm. *See* Aperture

Diffraction. The scattering of light waves as they strike the edge of an opaque material.

Diffused image. An image that appears to be soft and has indistinct edges, generally created by shooting or printing with a diffusing device.

Diffused light. Light that produces soft outlines and relatively light and indistinct shadows.

Diffuser. A translucent material that scatters light passed through it.

Diopter. A measurement of the refractive quality of a lens. Usually used in connection with supplementary close-up lenses to indicate their degree of magnification.

Dodging. The technique of giving less exposure to selected parts of an image during printing.

Double exposure. The exposure of two different images on a single piece of film.

Drying marks. Marks occasionally left on processed film after it dries. They can be avoided by use of a wetting agent and removed by careful rewashing.

Easel. A frame for holding printing paper flat during exposure.

Electronic flash. A short, bright artificial light produced by passing electricity across two electrodes in a gas-filled glass chamber.

Emulsion. A light-sensitive layer of silver halide salts suspended in gelatin and coated onto a paper or film base.

Enlargement. A print made from a smaller negative.

Enlarger. A device used to project and enlarge an image of a negative onto photographic paper or film.

Exposure. The amount of light allowed to reach a photographic emulsion.

Exposure factor. *See* Filter factor

Exposure latitude. The maximum change in exposure from the ideal exposure that will still give acceptable results.

Exposure meter. An instrument designed to indicate the amount of light either falling on or reflected by the subject.

Extension rings or tubes. Rings or short tubes that fit between the body and lens of a camera, designed to increase the focal length of the lens for close-up work.

Farmer's reducer. A solution, consisting of hypo (sodium thiosulphite) and potassium ferricyanide, used to lighten all or part of a black-and-white negative or print.

Fill flash. A flash unit used to supplement the existing light, particularly outdoors.

Fill light. A supplemental light used to reduce shadows and contrast caused by a main light.

Filter factor. The increase in exposure needed when filters are placed in front of the lens.

Fixer. A chemical solution that dissolves the remaining silver halides in an image, making it permanent.

Flag. A square or rectangular reflector attached to a stand.

Flare. Stray light, not part of the image, that reaches the film in the camera because of scattering and reflection within the lens.

Flatness. Lack of contrast in an image, caused by overly diffuse light, underdevelopment or underexposure, or flare.

Floodlight. A tungsten light and reflector.

Focal length. The distance between the center of a lens and the film when the lens is focused at infinity.

Focal plane. The plane behind the lens where the sharpest image from the lens falls; the plane of the film.

Fog. Density on a photographic emulsion

caused by accidental exposure to light or by processing chemicals and not part of the photographic image.

Fogging. In the camera, deliberately exposing the film to unfocused light, either before or after photographing a subject, in order to reduce contrast. In the darkroom, a usually accidental development of the film or paper because of something other than exposure (e.g., chemical contaminants).

Fresnel lens. A thin condenser lens with a number of concentric ridges on it, used to distribute brightness evenly in spotlights and viewing screens.

Fresnel screen. A viewing screen incorporating a Fresnel lens.

Front element. In a lens, the piece of glass furthest from the film plane.

Gamma. A number, derived from the steepness of the straight-line portion of the characteristic curve of an emulsion, indicating the degree of development the emulsion has received. The more developement the film has received, the higher the value of gamma and the greater the contrast.

Gelatin. The substance in an emulsion in which the light-sensitive particles of silver halide are suspended.

Gelatin filters. Colored filters that provide strong overall color effects.

Glossy paper. An extremely smooth type of photographic paper giving a great range of tones from pure white to pure black.

Gobo. A flat, black flag, usually a small circle or square, used to block or direct the light from a photo lamp.

Gradation. The range of tones, from white to black, found in a print or negative.

Grade. The measurement of the degree of contrast of a photographic paper, usually on a scale of 0 to 4.

Gray scale. A series of patches, joined together, of shades of gray ranging from white to balck in equal increments.

Ground glass. A sheet of glass ground to a translucent finish, used for focusing.

Guide number. A number on an electronic flash unit indicating its power.

H & D curve. A performance curve for a photographic emulsion, named for Hurter and Driffield, its developers and pioneers in the field of sensitometry.

Halation. The undesirable effect created when light passes through an emulsion, strikes the backing, and is reflected back through the emulsion, reexposing it.

Hardener. A chemical, usually incorporated into the fixer, that causes an emulsion to harden while drying, making it less susceptible to damage.

High-contrast paper. Photographic printing paper with a great deal of contrast, generally about grade 4.

Highlight mask. An intermediate positive or negative created to retain the highlights when duplicating.

Highlights. The areas of a photograph that are only barely darker than pure white.

Hot spots. A part of a scene or photograph that is relatively over-lit, often caused by poor placement of lights.

Hue. The name of a color.

Hyperfocal distance. When a lens is focused at infinity, the minimum distance at which it will record a subject sharply.

Hypo. Another name for sodium thiosulfate or fixer.

Hypo clearing bath (eliminator). A chemical solution used to shorten the washing time needed after fixing.

Illumination. The amount of light falling on a subject.

Incident light meter. A light meter used to measure the light falling on the subject.

Infrared film. Film sensitive to the infrared end of the spectrum, beyond the light visible to the human eye.

Intensifier. A chemical used to add density or contrast to a negative that is too thin for satisfactory printing.

Inverse square law. The principle that the amount of light falling on a subject varies in relation to the square of the distance between the light source and the subject.

Iron-blue toning. Adding a brilliant blue color to a print by using an iron-based toner.

Kelvin. The unit used to measure color temperature; the Celsius temperature plus 273.

Keystoning. A distortion of perspective that makes parallel lines appear to converge as they recede in the photograph.

Latitude. The amount of over- or underexposure a photographic emulsion can receive and still produce acceptable results.

Light cone. A cone made of a translucent material and used to diffuse evenly the light falling on the subject.

Light tent. A tent made of a translucent material, designed to be placed over the subject to provide shadowless, diffuse light.

Lighting ratio. A comparison of the amount of light falling on one side of the subject with the amount falling on the other side.

Line print. An outline effect created by sandwiching a positive and negative Kodalith of the same image and then making the print by passing light through the sandwich at a 45-degree angle.

Lith developer. A developer designed specifically for lith films.

Lith film. A very high-contrast film emulsion used for a number of darkroom special effects; Kodalith is the best-known brand.

Lumen. The amount of light reaching one square foot of a surface one foot from a light emitting one candela of intensity. The standard unit of measurement of luminance.

Luminance. The brightness of a light.

Mackie lines. In solarization or the Sabattier effect, the clear, undeveloped lines created where the positive and negative parts of the image meet.

Macro lens. A lens capable of very close focusing without supplementary close-up lenses, and usually capable of producing a 1:1 image on the film.

Macro photography. Photography that produces images generally ranging from one-half to ten times life-size. Images larger than ten times life-size are usually created by photography through a microscope.

Magenta. One of the three subtractive primary colors; the others are cyan and yellow.

Mask. A device used to modify or hide part of an image during printing.

Matte. A descriptive term for any surface that is relatively nonreflective.

Mid-range. Those tones in a scene that fall midway between the darkest and lightest tones.

Mired. A measurement of color temperature used to find the difference between light sources and calculate the effect of color filters.

Modeling light. A small spotlight that can be precisely directed.

Montage. A composite picture made by combining elements from different photographs together.

Motor drive. A device used to advance film automatically through the camera, often at greater speeds and with more versatility than an autowinder.

Munsell system. A systematic method of color classification based on the three dimensions of color: hue (the name of the color), value (its lightness), and chroma (its saturation).

Negative carrier. A holder used to position the negative correctly between the enlarger light and the enlarger lens.

Neutral density filter. A filter, available in varying intensities, that reduces the amount of light reaching the film without affecting its color.

One-shot solution. Any processing solution designed to be used once and then discarded.

Opaquing. 1. The technique of covering parts of a negative with an opaquing solution to block out the image in that area. 2. To fill in pinholes in Kodalith negatives or positives with an opaquing solution.

Orthochromatic. An emulsion, either paper or film, that is sensitive to green, blue, and ultraviolet light and can be handled under a dark red safelight.

Overdevelopment. Development for longer than the recommended time.

Overexposure. Exposure for longer than the recommended time.

Panchromatic. Sensitive to all the colors of the visible spectrum.

Panning. Moving the camera to follow a moving subject and keep it continuously in the viewfinder.

Parallax. Of particular importance when using non-SLR cameras, parallax is the apparent movement of objects relative to each other when seen from different places.

Photoflood. A tungsten light with a color temperature of 3400° K.

Polarized light. Light that vibrates in only one plane rather than many.

Polarizing screen. A rotating filter attachment that allows light vibrating in only one plane to pass through the lens.

Posterization. A high-contrast printing procedure producing a print with only two or three (sometimes more) tones.

Primary colors. Any three colors that can be combined to make any other color. In additive color, the primary colors are red, green, and blue; in subtractive color, the primary colors are yellow, magenta, and cyan.

Printing frame. A frame used to hold the negative and paper together when exposing a contact print.

Pull processing. Intentional underdevelopment of a film or paper, usually because it has been overexposed.

Push processing. Intentional overdevelopment of a film or paper, usually because it has been underexposed.

Quartz-halogen lamp. A tungsten-balanced photo light that burns brightly and evenly with consistent color temperature over a long period.

Reciprocity failure. During very long or very short exposures, the law of reciprocity no longer holds and film shows a loss of sensitivity, resulting in underexposure, and color changes in the case of color film.

Reciprocity law. The amount of exposure a film receives is the product of the intensity of the light (aperture) times the exposure time (shutter speed). A change in one is compensated for by a change in the other.

Reducer. A chemical solution used to reduce the density of a negative or print.

Reflected-light reading. A light reading taken by pointing the meter at the subject and measuring the light reflected from it.

Reflector. Any surface used to direct light onto or near the subject.

Replenisher. A solution added to a larger amount of the same solution to maintain its strength as it is depleted by use.

Resin-coated (RC) paper. Photographic printing paper with a plastic backing. RC paper dries quickly without curling.

Reticulation. A crazed pattern of cracks in the photographic emulsion, caused by a sudden change of temperature during processing.

Reversing rings. Adapters enabling the camera lens to be reversed and mounted for close-up work.

Rising front or standard. On a view camera, a lens panel that can be moved up or down.

Sabattier effect. The appearance of areas of both a positive and negative image on a film or paper, caused by brief exposure to light during development.

Safelight. A colored light that does not affect the photographic material in use. E.g., a dark red light used when processing orthochromatic film.

Saturation. The purity of a color; the more white light the color contains, the less saturated it is.

Scrim. A translucent material used to diffuse light shining through it.

Selenium toning. Adding a rich brown tone to a print by using a toner containing selenium.

Sensitometry. The exact measurement of the sensitivity of film and paper.

Sepia toning. Adding a brown or sepia color to a print by using a sulphide-based toner. Sepia toning adds interest and permanence to a print.

Silver halides. A general name for a group of light-sensitive chemicals used in photographic emulsions.

Skylight filter. A filter used to absorb excess ultraviolet radiation.

Snoot. A conical attachment for a photo light used to concentrate the light into a small, circular area.

Soft box. A light with built-in reflectors, giving diffuse light with soft shadows.

Soft-focus lens. A lens designed to give an image that is less than sharp and is slightly diffused.

Solarization. The creation of a combination

of a partially positive and negative image when a negative is greatly overexposed.

Split-focus lens. A lens attachment that is clear glass on one half and a plus-diopter close-up lens on the other, allowing a close foreground and a distant background to both be in focus.

Spotlight. A light source that gives a concentrated beam of light producing sharp shadows.

Spot meter. A hand-held exposure meter with a very narrow angle of view, used for measuring reflected light at a specific point.

Stock solution. Any processing solution that can be premixed and stored for later use in lesser amounts.

Stop bath. A chemical solution used to end the action of a developer.

Strobe light. An electronic flash unit.

Strobe meter. A flash exposure meter.

Sweep table. A table with a surface of translucent plastic that can be lit from underneath.

Swings. Horizontal movements on the front and rear standards of a view camera.

Target. A small, circular gobo.

Test strip. A series of different exposures on a single piece of paper or film, used to find the optimal exposure.

Tilts. Vertical movements of the front and rear standards of a view camera.

Tonal deletion. The elimination of shades of gray from a print, producing a high-contrast print using only black and white.

Tonal range. The gradations of gray between the darkest and lightest areas of a print or scene.

Toner. A chemical that adds color to or changes the color of a black-and-white print or negative.

Tone separation. *See* Posterization

Tungsten light. A lightbulb containing a tungsten filament and giving light with a color temperature of about 3200° K.

Ultraviolet filter. *See* Skylight filter

Ultraviolet radiation. Invisible energy just below the short-wavelength end of the visible spectrum, and present in many light sources.

Variable-contrast paper. Black-and-white printing paper that gives a range of contrast grades, depending on the filtration used in enlarging.

View camera. A large-format camera with movable front and rear standards joined by a bellows.

Vignetting. Darkening in the corners of an image, caused by the instrusion of the lens hood or filter into the subject area.

Warm-tone developer. Paper developer that gives a brown-black color to the image on the photographic paper.

Wetting agent. A chemical added to the last processing wash to ensure even drying.

Yellow. One the primary additive colors.

Zone System. A method for converting light measurement into exposure settings by analyzing the tonal range of the subject and dividing it into numbered zones.

Index

Numbers in italics indicate information in captions.